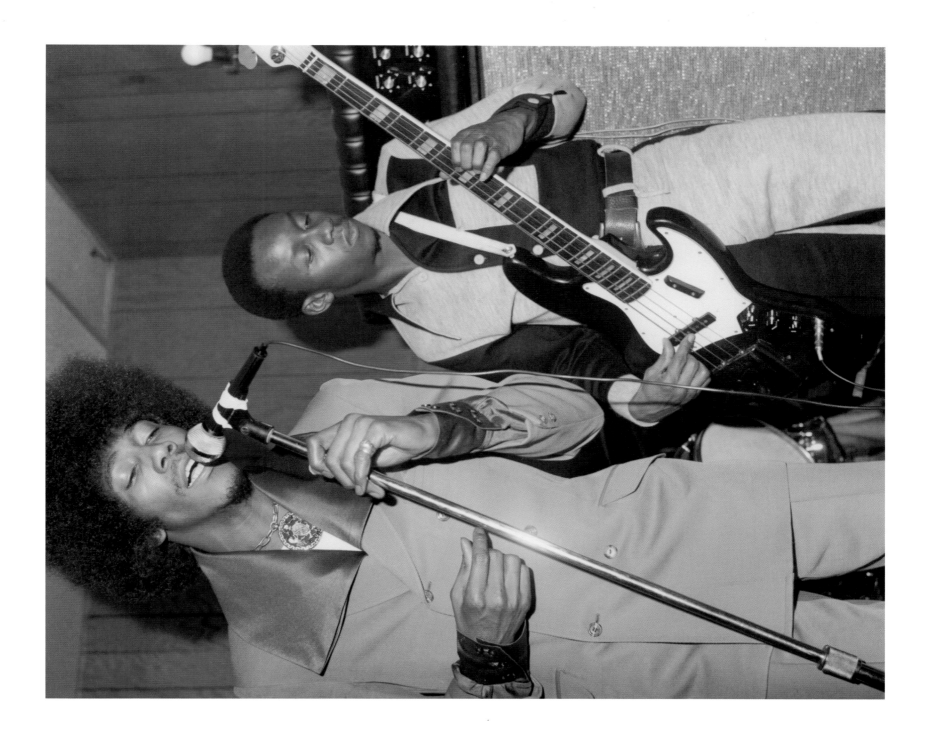

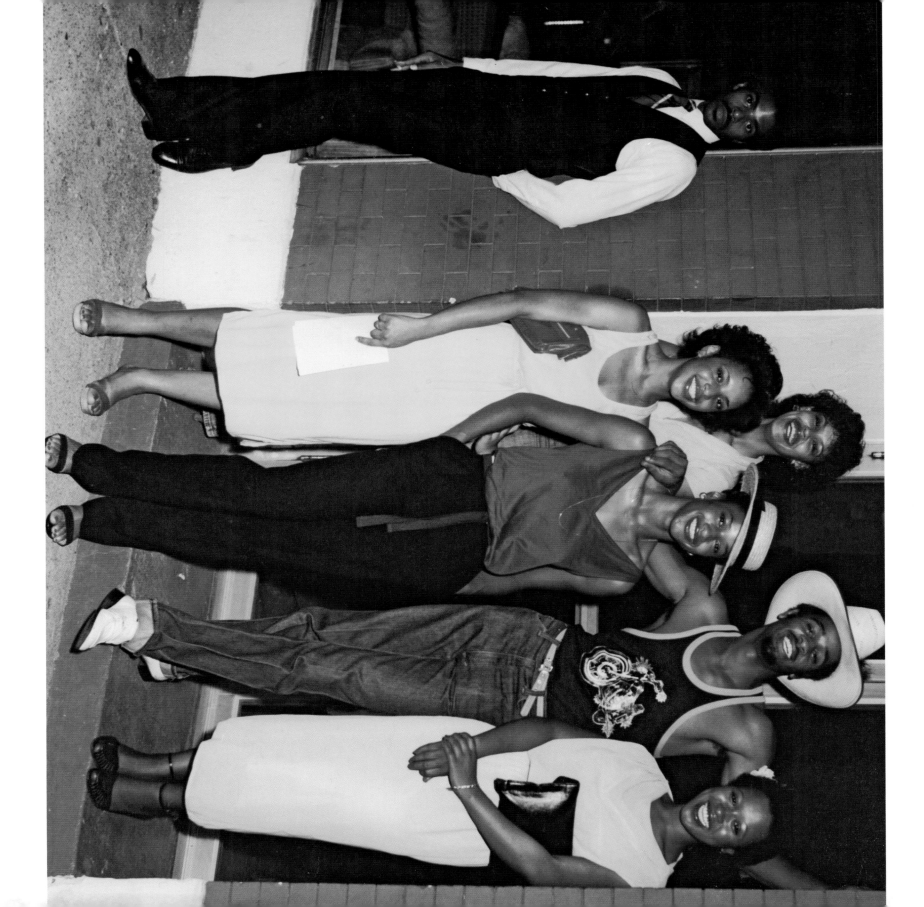

SiGHTS, SOUNDS, SOUL

THE TWIN CITIES

THROUGH THE LENS OF CHARLES CHAMBLIS

PHOTOGRAPHY BY
CHARLES CHAMBLiS

TEXT BY
DAVU SERU

MINNESOTA HISTORICAL SOCIETY PRESS

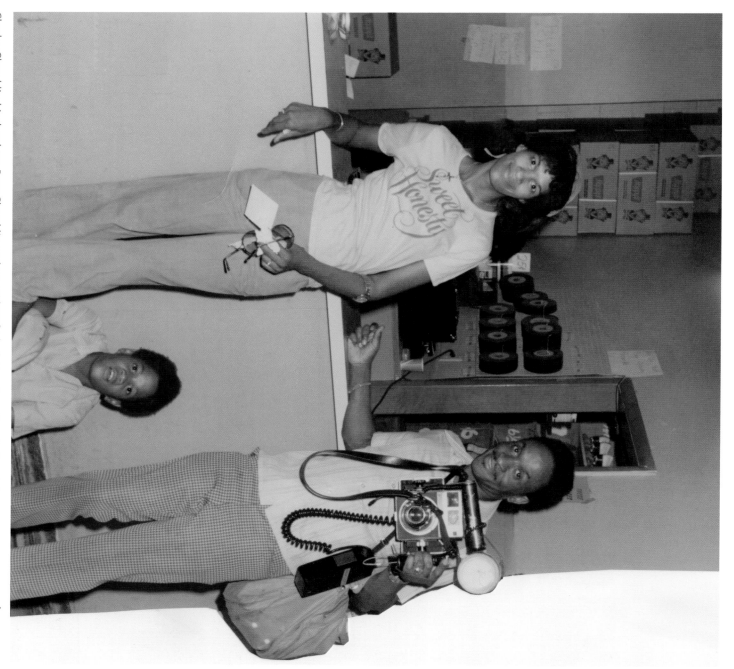

Charles Chamblis, his daughter, Reva Chamblis, and an unidentified relative at a roller-skating rink

SIGHTS, SOUNDS, SOUL

When you look at me,
Know that more than white is missing.

—Thylias Moss, "Lessons from a Mirror"

A T FIRST GLANCE, the work of documentary photographer Charles Chamblis (1927–91) beckons some Twin Cities viewers to return to a place both real and imagined. The photographs conjure a nostalgia shared by all the senses. Images burned into the mind—the deeper the mental image, the deeper its impression on a body and the body politic.

"The smell of the cameras, that's the memory that sticks with me," recalls Reva Chamblis, daughter of the photographer known to some as "Pictureman," to others, "Cameraman."

Recollected, the photographs compose a story—a story about a black photographer among other black photographers, about a series of places we might call "black Minnesota," and about a Minneapolis sound underexposed, until recently.

"It helps to see it," says DJ Brian Engel, connoisseur and collector of the Minneapolis Sound. The collection of 45s turns out to be a half a loaf of bread in size. A glimpse of a brief moment in time.

What's been recorded of the Minneapolis Sound has been recovered and anthologized—by a predominately white and male community of audiophiles—in the collections *Twin Cities Funk & Soul: Lost R&B Grooves from Minneapolis/St. Paul, 1964–1979* and *Purple Snow: Forecasting the Minneapolis Sound.*

But the sound was also a cultural community that, according to singer Kym "Mocha" Johnson, had Chamblis not captured it on film, "no one would know."

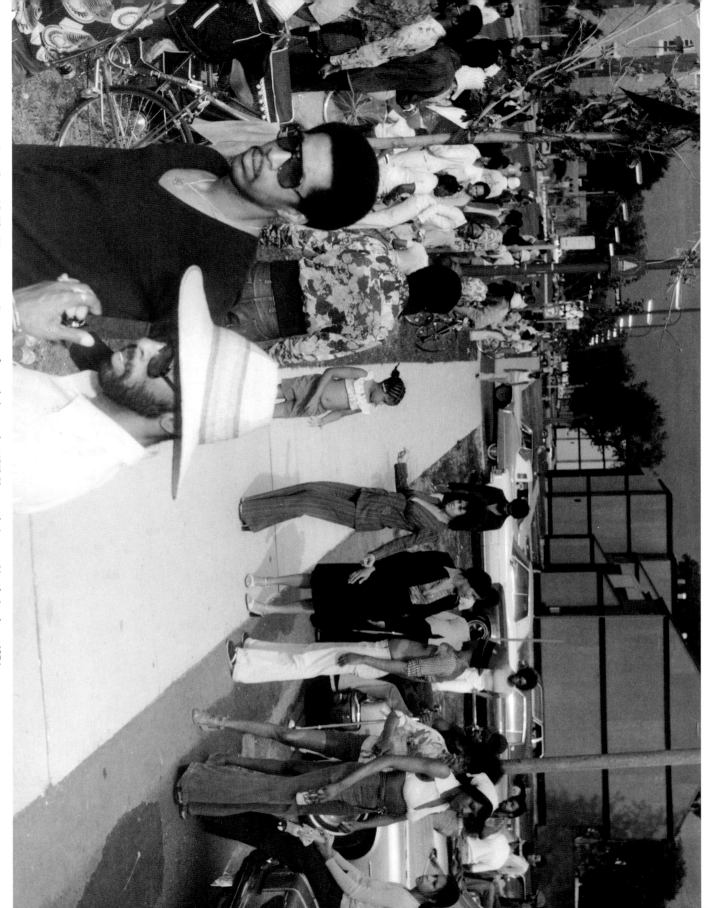

Crowd outside The Way community center, formerly located at 1913 Plymouth Avenue North, in about 1976

Sense and soul of the ordinary and extraordinary left for us to go back and get it. This is the scene, the intersection where a collection of photographs allows us congress with the forces guiding our past, and our present, courtesy of Charles Chamblis. Look and listen.

• • •

Chamblis was born in Pittsburgh in 1927 during the waning days of the New Negro Renaissance most famously centered in Harlem. The proverbial motherless child, Chamblis turned to the arts early on in order to render hard times in terms poetic. Following an honorable discharge from service in World War II, the former Marine and budding aesthete relocated to Minnesota in 1958, adding his number to the 436 percent increase in Minneapolis's black population between 1950 and 1970. It was there, nearing the age of thirty, that he received his first camera from his wife, Jeannette, his companion on the "Great Migration."

While being a beacon of more freedom than many had known, the North Star State has most certainly not always felt like "home" for black Minnesotans. Like elsewhere, the state's black citizens faced a harsh reality that included restrictive housing covenants, employment discrimination, and segregation in many areas of daily life, including entertainment. But bittersweet blooms so often come bursting out of the black bottom and northern ghettos, sounding out one of the great ironies of American life.

Chamblis took up the task of documenting the blooms—"the best" of what the black Twin Cities had to show itself and that very consequential gaze of others. For this, the tale born out of his life's work—the tale of our Twin Cities—is an episode in another: the politics of race and visibility in the United States.

"It is a peculiar sensation, this double-consciousness," wrote W. E. B. Du Bois in his seminal work *The Souls of Black Folk* in 1903, "this sense of always looking at one's self through the eyes of others, of measuring one's soul by the tape of a world that looks on in amused contempt and pity."

As early as the late nineteenth century—before the Great Migration of black folks from mostly rural and impoverished communities in the South—black photographers like D. E. Beasley, R. Harry (Henry) Shepherd, and James Presley Ball worked diligently from their Twin Cities studios and elsewhere to capture and circulate images of African American progress and upward mobility. In fact, citing advertisements in St. Paul's *Western Appeal* newspaper, scholar Deborah Willis has noted, "There were many successful commercial photography studios in Minneapolis and St. Paul in the last quarter of the nineteenth century. The People's Photo Gallery was

George Bonga, the first known black Minnesotan, circa 1870. Photo by Charles A. Zimmerman.

Cabinet photograph of lawyer and civil rights activist Fredrick McGhee, circa 1890. Photo by Harry Shepherd.

owned by one of the earliest black photographers in the city, R. Harry Shepherd, who opened his studio in fall of 1887."

During his brief stay in the Twin Cities, the itinerant James Presley Ball loaned his eye as the official photographer of the region's public celebrations of the twenty-fifth anniversary of the signing of the Emancipation Proclamation. He also produced a daguerreotype from his Cincinnati studio of one of the most photographed people of the nineteenth century, Frederick Douglass.

That a fugitive slave and rhetorician like Frederick Douglass would submit his image to camera so often indicates how well he understood the role of optics in the fight for racial justice—as did Ball and as would many contemporaries and civil rights activists such as Du Bois and Booker T. Washington, who advocated that one show one's "best self." Pioneering black filmmaker Oscar Micheaux brought images of African Americans and themes of class and racial injustice to the silver screen in the early years of motion pictures during the volatile post–World War I era. "It is only by presenting those portions of the race in my pictures, in the light and background of their true state, that we can raise our people to greater heights," Micheaux asserted.

But the migration of poor, mostly illiterate rural blacks to urban centers also affected the politics of visibility and representation in ways that frustrated the efforts of the established black political class.

The Great Migration happened in three phases: first came the southerners after Reconstruction, then the post–World War II crowd, then those, like Chamblis, looking for opportunity in Lyndon Baines Johnson's "Great Society." In all cases, these migrants brought plenty with them from their various regions of origin, much of it impalpable.

Like Depression-era projects of Walker Evans and Dorothea Lange, many photographers after the fall of the black cultural renaissance in Harlem and elsewhere moved from documenting cultural achievements to chronicling economic depression among black folk who landed in slums after having migrated north.

Black writer Richard Wright and white photojournalist Edwin Rosskam's government-supported pictorial, 12 *Million Black Voices* (1941), provides an unvarnished representation of black life. If not intending simply to shock white audiences into action, Wright and Rosskam presented plain evidence of the irony in that "American Dream" introduced during the Great Depression. As Wright wrote: "This text assumes that those few negroes who have lifted themselves, through personal

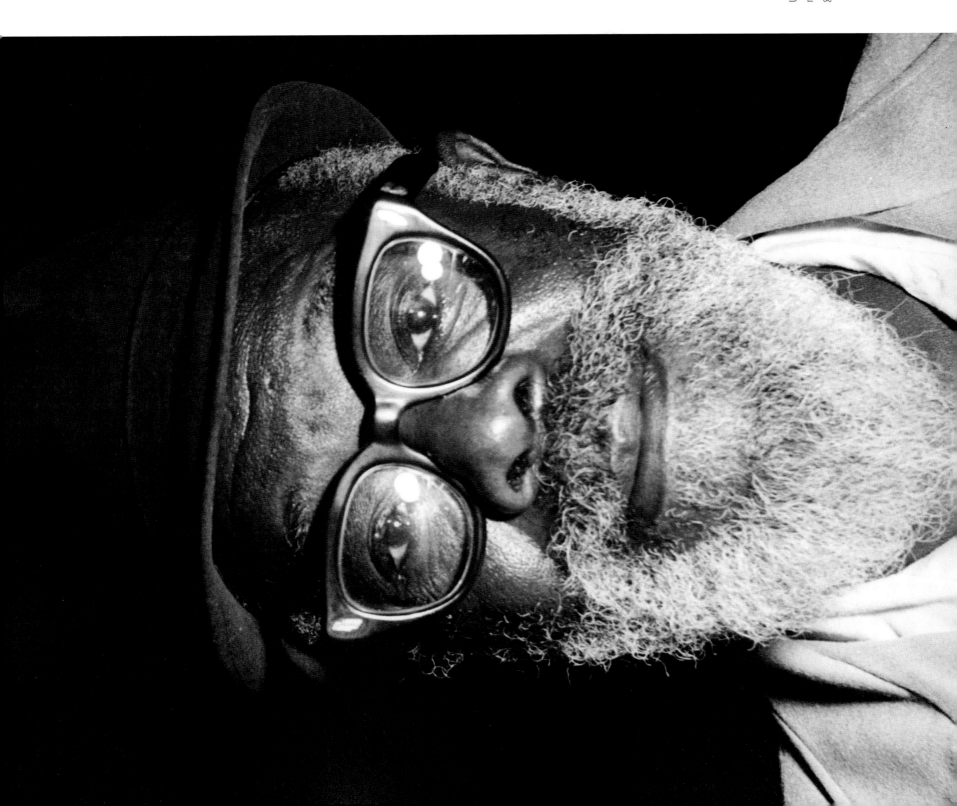

strength, talent and luck above the lives of their fellow blacks—like single fishes that leap and flash for a split second above the surface of the sea—are but fleeting exceptions to the vast tragic school that swims below in the depths, against the current, silently and heavily, struggling against the waves of vicissitudes that spell a common fate."

It helps to see it, yes. But, as Susan Sontag explained in *On Photography*, notwithstanding political motivations, the setting in these photos often spoke for the subjects rather than allowing the subjects to speak for themselves. To be cast as environmentally determined is to be cast as an object of pity or horror and, therefore, not fully human. On the other hand, composed portraits of respectable citizenry placed the often-isolated subject at center, at the command.

In Charles Chamblis's photos, churches, nightclubs, city lakes, well-groomed yards, hotel rooms, event centers, and street scenes speak of a different sort of subject: a community in full possession of itself. This approach was no doubt meant to contest the other, and this is why we treasure him. "There is only one game in town," Chamblis wrote in his daybook, "and that is reality."

Chamblis and the things he carried landed in Minneapolis north-northwest of downtown in an area of the city which has suffered from a race-conscious society's most embarrassing truths for some time—but it has also suffered from poor optics.

North Minneapolis, like the Rondo neighborhood of St. Paul the longtime center of black life in the Cities, has carried a peculiar burden: To those who gaze from outside the interpretative circle, it is a violence-ridden slum. For those, like Chamblis, who operate from within, it is imagined as two black worlds, one bearing more of the responsibility for the other, but also as everything that humanity is capable of all at once.

In the name of urban renewal and efforts to link ever-increasing suburban flight back to the urban hub, a new interstate 94 replaced Sixth Avenue, a portion of the north side that a map of "Vice Areas" from 1936 identified as the "largest Negro section in the city." In fact, restrictive housing covenants ensured that, by 1930, 50 percent of all black Minneapolitans lived within the city's so-called vice areas. Twin Citizen W. Harry Davis recalled that, during Prohibition, the district overrun by mobsters was the "hell hole" of Minneapolis. "Why they called it the hell hole.... There were people murdered on the street, drive-by shootings where they'd get in some of those speakeasies and get to fighting and kill each other, stab them or shoot people. That's the kind of environment we were in, but all along Sixth Avenue, there was drug stores, grocery stores, restaurants, dry goods stores where you could buy clothing, laundries, tailor shops, barbershops, everything that you could think of."

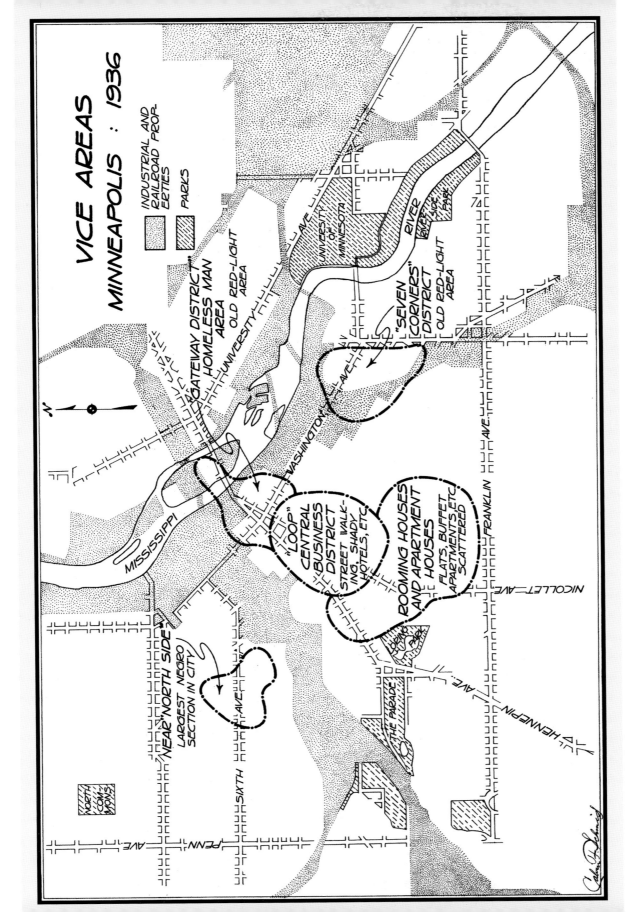

VICE AREAS
MINNEAPOLIS : 1936

INDUSTRIAL AND RAILROAD PROPERTIES

PARKS

GATEWAY DISTRICT HOMELESS MAN AREA

OLD RED-LIGHT AREA

UNIVERSITY OF MINNESOTA

"SEVEN CORNERS" DISTRICT

OLD RED-LIGHT AREA

"LOOP" CENTRAL BUSINESS DISTRICT

STREET WALK-ING, SHADY HOTELS, ETC.

ROOMING HOUSES AND APARTMENT HOUSES

FLATS, BUFFET APARTMENTS, ETC. SCATTERED

"NEAR NORTH SIDE"

LARGEST NEGRO SECTION IN CITY

NORTH COM-MONS

MISSISSIPPI

THE PARADE

PENN AVE

SIXTH AVE

FRANKLIN AVE

NICOLLET AVE

6TH HENNEPIN AVE

Map of Minneapolis's "Vice Areas" from Calvin Schmid's *Social Saga of Two Cities: An Ecological and Statistical Study of Social Trends in Minneapolis and St. Paul*, published in 1937

Likewise, in his Great Migration narrative *A Choice of Weapons*, Gordon Parks, the most highly regarded black American photographer and a former Twin Cities resident who would bounce between Minneapolis's Near North side and St. Paul's Rondo, recalled scenes from "Pope's" north side brothel in the black bottom. In his book *Arias in Silence*, curious reader illustrations of life in the black bottom. In his book *Arias in Silence*, he wrote, "The pictures that have most persistently confronted my camera have

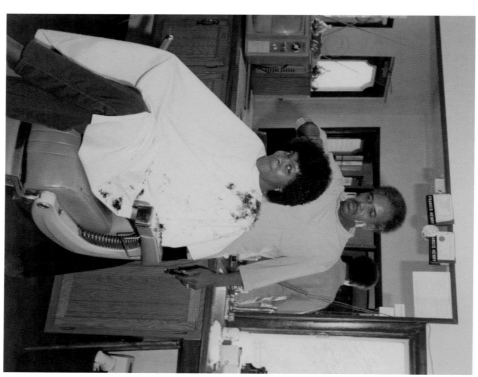

Barber Francis Henry cutting Virgie Robinson's hair at a shop located at Plymouth and Queen Avenue North

been those of crime, racism and poverty. I was cut through by all three."

Nevertheless, the black life that Parks chose to display in still and moving images was cast as heroic and, therefore, treated as the subject of high art. This was both his selective intention and the imaginary outcome: a black world not trapped by time and circumstance but subject to development and ofttimes fickle Fates.

With the rise of local and national civil rights activism, employment and housing prospects for black people in the Twin Cities vastly improved by the 1970s, and North Minneapolis was known as the cultural center of a new generation of black residents one generation removed from Chamblis. The non-natives made their way to Minneapolis not only from the south but also from other midwestern cities like Detroit; Gary, Indiana; East St. Louis, Illinois; Dayton, Ohio; and Chicago. And they would have to settle somewhere within the *de facto* restricted areas.

Torrie Jones, a Chicago native and former member of the Blackstone Rangers street gang, made the Great Migration to Minneapolis amid the third wave of the late 1970s. Having come of age just a few blocks from Chicago's notorious Cabrini-Green housing projects, Jones remembers that, in North Minneapolis, "there were no gangs. Less violence. It was safe. I was tired of getting shot at."

Jones's final push to move to the Twin Cities was in pursuit of a girl. One day, while making the rounds of local businesses on Penn and Plymouth Avenues—or, perhaps, in need of a haircut—Charles Chamblis headed over to a salon, knowing better than to leave his camera at home. In one chair sat Virgie Robinson, former girlfriend and rival Chicago gang member of Torrie Jones. The couple had settled down just a few doors from the shop they would frequent, but they separated soon after. Chamblis captured these blooms for posterity.

Ames Hall Elks Drum and Bugle Corps during the first month-long observation of black history in Minneapolis

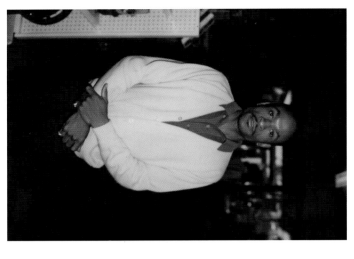

The Pictureman in a Minneapolis camera shop

On another day, in 1976, Chamblis was at the Plymouth Avenue Elks Lodge, not far from his home. The Benevolent and Protective Order of Elks Ames Lodge has provided the black community in North Minneapolis a private space to meet with other black people for, among more noble things, a drink. Before 1949, when entrepreneur and labor organizer Anthony Brutus Cassius opened Cassius Bar and became the first black business owner to receive a liquor license, there was not a public black establishment where a black person could legally drink and socialize.

On February 21, 1976, near the end of the first observance of Black History Month, Chamblis gathered the Elks Drum and Bugle Corps and snapped a photo. These people were Brights, Underwoods, Buckhaltons, Doughtys, Couyers, Spears, and others. Once the photo was developed, Chamblis either collected for it or said, "It's okay, catch me next time!"

Friends and family recall that Chamblis's precarious business model and willingness to "give you the shirt off of his back" often left him short on funds. A former employee of Liberty Photo in South Minneapolis, who processed nearly five hundred rolls of film per day, remembered that Chamblis was well known in the lab—for his bounced checks as well as his friendliness.

Occasionally Chamblis would land a more reliable freelance gig. *Insight News* put out a call for photographers in early 1977. Chamblis appeared in the photographer roster in the July 15, 1977, edition, only to be removed later that year. Prior to that, the photographer captured images for the pictorial history that "race man" and rogue publisher Walter R. Scott produced, *Minnesota's Black Community* (1976). In his lifetime, Scott (1929–2001) published three pictorials of the black Twin Cities, the two others being *Minneapolis Beacon: Featuring the Negroes of Minnesota* (1956) and *Minneapolis Negro Profile: A Pictorial Resume of the Black Community, Its Achievements, and Its Immediate Goals* (1968). Texts like Scott's serve rhetorical ends like those of Frederick Douglass and the race leaders of the late nineteenth and early twentieth centuries, but with a difference.

In *The Black Bourgeoisie*, the classic 1957 study of the black middle class of the 1940s and '50s, E. Franklin Frazier cautioned against too hastily assimilating white American ideals at the expense of a cultural rootedness in black community. In the era of increased integration, the chances of "selling out" one's native community in order to be melted in the pot was too great. Respectable black publications like *Minneapolis Negro Profile* and *Minnesota's Black Community* might be read as responses to this call by Frazier. While Scott's publications certainly withhold images of life among the especially lowly, they nevertheless commit themselves to the work of racial uplift with both a black and white audience in mind.

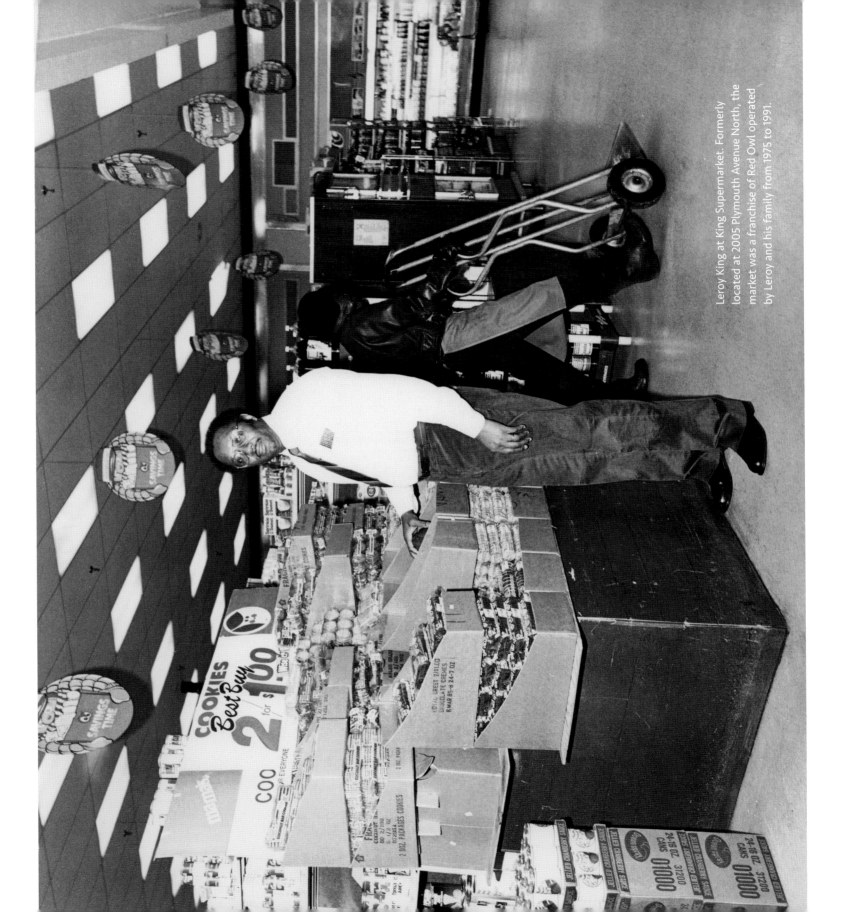

Leroy King at King Supermarket. Formerly located at 2005 Plymouth Avenue North, the market was a franchise of Red Owl operated by Leroy and his family from 1975 to 1991.

The introduction to Scott's 1968 publication states, "This book is for everyone. For everyone who needs to know the truth about the Negro in Minneapolis. . . . Two groups of Minneapolitans particularly need this book: white businessmen and black youth."

Readers familiar with the contemporary rhetoric of "opportunity" and "achievement" when discussing racial disparities in education and wealth will likely recognize the same here: the white businessmen offer the opportunity, the black youth prove their value through achievement, pictorials like the *Minneapolis Negro Profile* helping both parties imagine what's possible. But, presumably having received the message of *The Black Bourgeoisie*, the pictorial also includes evidence of efforts to establish pride in black history, culture, and community.

While Chamblis often composed photos to show black civil order and discipline—photos that harken back to Harlem Renaissance–era photographer James Van Der Zee's pictures documenting Marcus Garvey's United Negro Improvement Association—many depict middle-class black life as so caught up in the moment that he risks their seeming too banal to be aesthetically interesting. In some cases this is conveyed through images of black business owners like Leroy King, who smiles pleasantly in front of his cookies display at King Supermarket but perhaps wonders what all the fuss is about; a company softball team out for a post-game beer at Jersey's Sports Bar; or young dancers having too much fun under the neon glow of "Dance Your Ass Off" to care about assimilating much of anything. Like their nineteenth-century predecessors concerned with documenting the "ordinary," Chamblis's photos sometimes simply document time, person, and place. Inconspicuous history made remarkable. But why?

Since the middle 1980s, North Minneapolis has survived the introduction of crack cocaine, the emergence of gangs to administer the distribution of it and guns to aid them in their vying for dominance, the collapse of local businesses, and the precipitous flight of a chunk of its middle-class population.

Chamblis's photos recall a time when the funeral parlor was not one of the most visible private businesses on Plymouth Avenue, but a black-owned supermarket was. A time when porch-sitting elders were a visible presence in the community, and all childhood mischief was telephoned home before you got there. A time for our own roller-skating rink. Before the infamous Fourth Precinct police station replaced the new Way community center that gave people a place to be young, black, and visible without being a threat to anyone.

A time not far off but too near forgotten—we Minnesotans are perhaps most comfortable in our farsightedness. Images of the first known black Minnesotans,

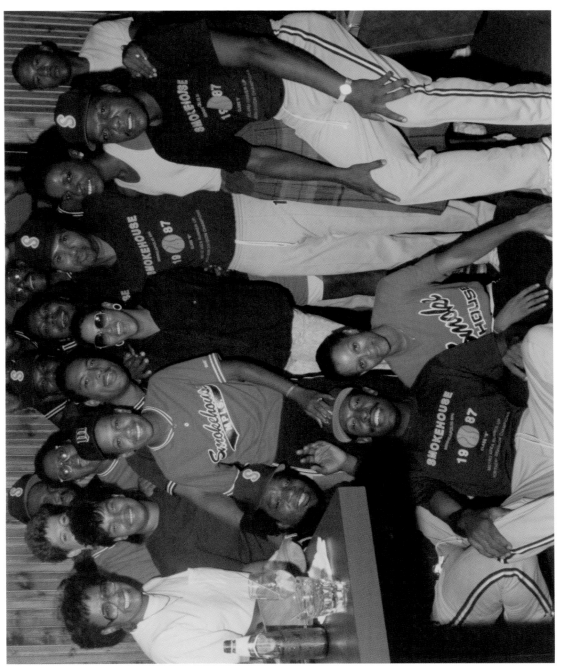

Group at Jersey's Sports Bar

father and son Pierre and George Bonga, and of early civil rights leaders like Frederick McGhee and Gertrude Brown call on homesickness for the triumphs of the past—the frontier and what we've overcome, as evidenced by picturesque gentlemen and ladies who stand as examples for a present that was never fully legible to most. For, assuming we've bothered to look, the lives of black Twin Citizens in the 1970s and '80s may until now—until Chamblis—have been too close to see.

• • •

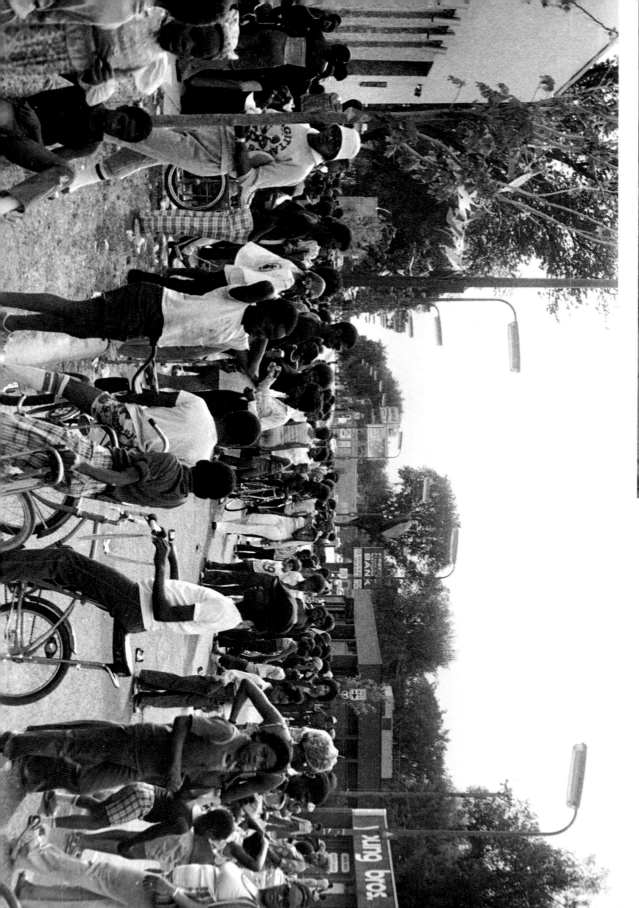

Event outside The Way community center. The Way community center would eventually be charged with fomenting radicalism among north side youth.

Northgate Roller Arena, formerly located at 1200 Plymouth Avenue North. As host of a historic Kurtis Blow concert, it became an important site for hip-hop in Minneapolis.

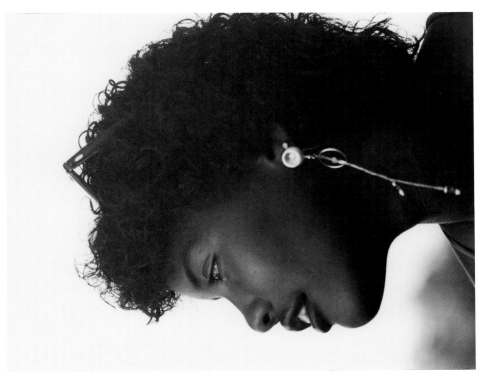

Woman with a gold earring in profile

In 1975, while Chamblis was trying to make a career for himself as a photographer of black life in Minneapolis, French filmmaker Jean-Luc Godard declared that Kodak film is racist. Imagine: Kodak determined that the standard for properly exposing skin color is a white woman named Shirley. If you are black, stand anywhere near Shirley in the photo and you are bound to disappear or become too present to be legible. You are black; she is white.

When asked about processing negatives featuring black subjects in the days of the Shirley card, Chamblis's one-time photo tech at Liberty Photo, a white man, responded that, aided by Kodak C-41 control strips, "we just tried to go for what looks natural." He adds: "We didn't have many problems with exposure because, frankly, we didn't process many photos of black people."

"I can take a better picture if I know what I'm looking at," wrote Chamblis in one of his daybooks.

Shirley cards or no Shirley cards, the miscellany of the photos that he captured begs the question: If photographic contrast is such a zero-sum game—if conditions provide that we are bound to exist at the expense of the other—then why does Chamblis seem to so often get it right?

Pictureman to some, Cameraman to others. In his work, Pictureman appears to outdo Cameraman in the battle of representation, finding the picturesque in black, despite the shortcomings of Kodak film. Memories recollected, but fading. Resin-coated paper. Three layers of color: "It was not intended to last," remarks photographer Chris Farstad. No doubt, immediacy is what you sense.

Insight News editor in chief Al McFarlane remembers that Chamblis "knew exactly what he was doing," adding, "he was a visionary."

What makes a photograph from the 1970s look like a photograph from the 1970s? "The way it fades," says photographer Chris Faust. Beautifully ordinary. Not long ago, but remarkable.

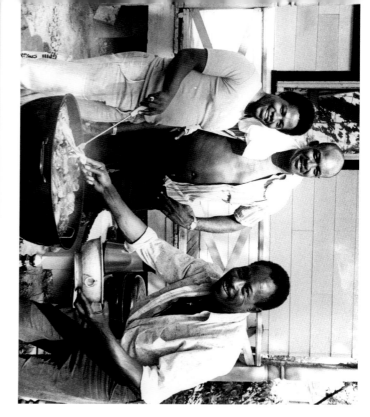

"It is exciting to see his work come back to light," says an old Liberty Photo tech.

Is there such a thing as a black photographer? There is a "black motive," replies North Minneapolis resident Bill Cottman, photographer of enshrined memorials to the neighborhood's fallen, spectacular images that have become tragically ordinary.

Black motive: It's 1955 and Emmett Till's mother chooses an open casket so that the lynched and brutalized body of her son would be seen and be photographed by the *Chicago Defender* newspaper.

Black motive: Document the evidence of our treatment as black. And the blooms, too.

With Chamblis we have the embedded native documenting both for the sake of aesthetic pleasure and for the historical record. But his subjects—black Twin Citizens—dwell in valleys guarded from peaks of hypervisibility: Dred Scott at Fort Snelling; lynchings in Duluth; violence against the Lee family, attempting to buy a home at Forty-Sixth Street and Columbus Avenue; brewery boycotts; Double-V campaigning; NAACP pickets at Woolworth; Plymouth Avenue "race riots"; Black Power at Morrill Hall; Murderapolis. In contrast to these high-profile moments of racial disharmony, Chamblis was capturing the remarkably ordinary—what Gordon Parks called "moments without proper names."

If, as McFarlane says, Chamblis also "knew that what he was doing was important," then he was committed to the work of service. Musician Anthony Scott and radio DJ Thornton Jones remember that wherever Leland "the Wing Man" Carriger used to be, the Pictureman would be toting his Graflex XL press camera, or perhaps his Polaroid, and portable backdrop. Both would be selling their wares to hungry club-goers wanting a memento—the "Wing Man" with salty chicken wings wrapped individually in

Top: Three men happily grilling

Left: Children wading in Lake Calhoun, named in honor of notorious proslavery statesman John C. Calhoun. The lake is now known as Bde Maka Ska.

Man throwing fire at the Taste
Show Lounge; Chamblis Photo
Catering Service poster in
background

aluminum foil; the Pictureman with snapshots of people at, say, the Nacirema Club making a place for themselves.

• • •

Time ebbs and flows. And it will. Spaces come and go. And they will. Memory moves with and resonates from its people. Chamblis captured the movements in the local vernacular of a new and regionally peculiar breed that would, for a time, organize itself around a sound.

Iconic scenes like Philly and Chicago Soul, Berry Gordy's Motown, and Memphis's Stax are all indicators of what black people came together and decided to do with their freedom within a network of rivalry and influence made possible through recorded music, black radio, and television shows like *Soul Train.*

So, too, is the case for the black Twin Cities. However, what these other cities do not have is Minneapolis and St. Paul's intensely stated "minority" problem, where interracial mixing and tensions are so often in play and hardly ever settled on the stage or dance floor.

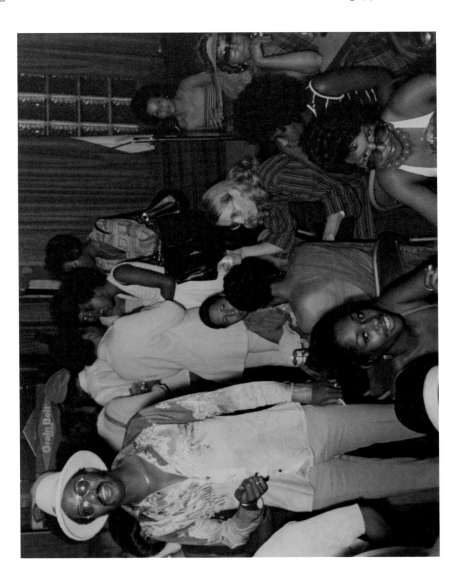

Customers at Nacirema Club,
3949 Fourth Avenue South

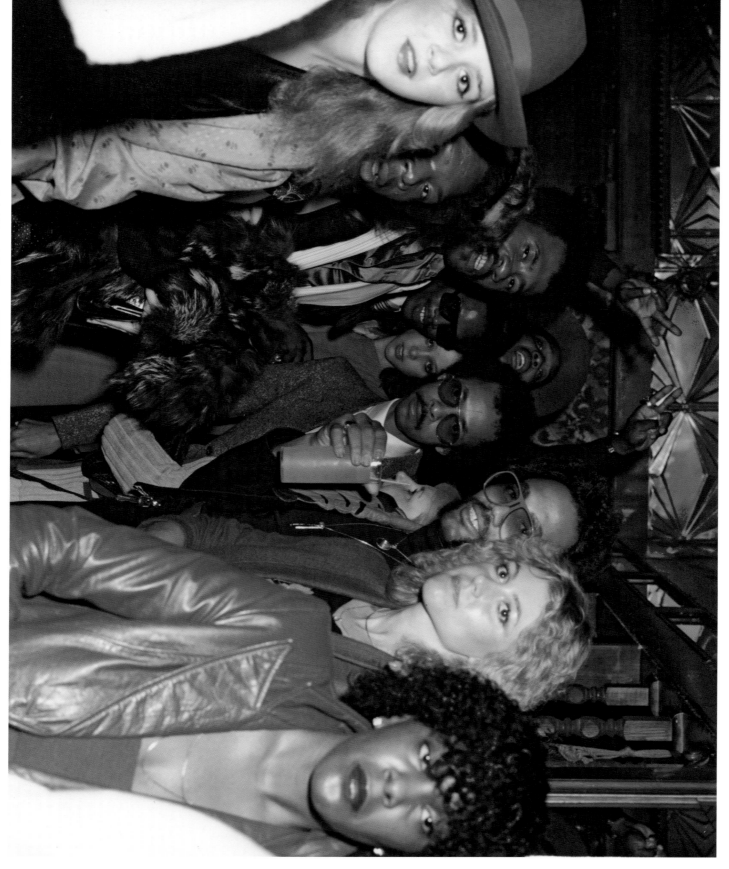

A group out clubbing at the Flame, 1523 Nicollet Avenue South

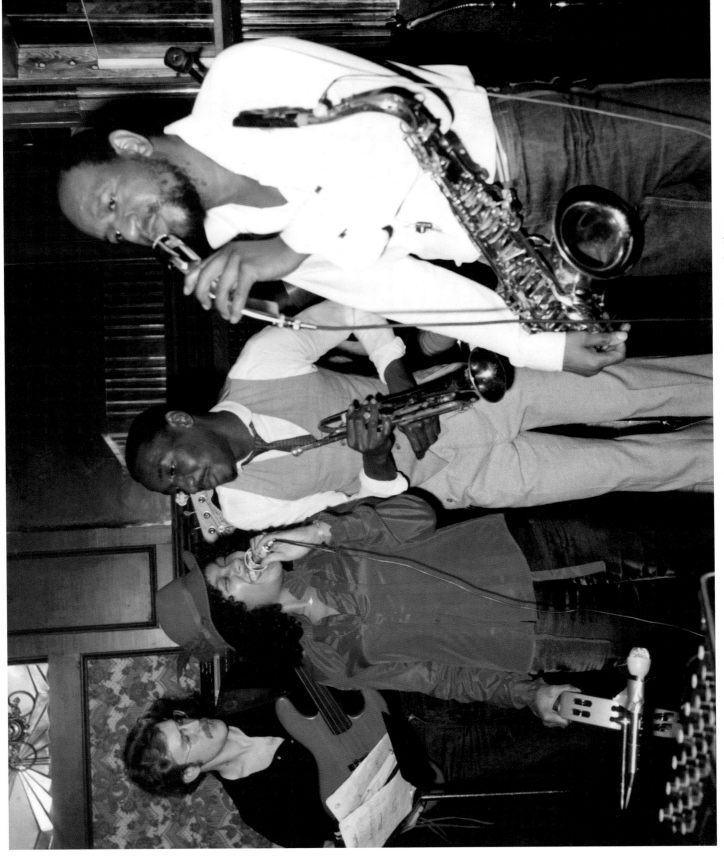

Saxophonist Morris Wilson, trumpeter Charles Bivens (second from right), and unidentified musicians at the Flame

Maurice McKinnies in pompadour and satin with unidentified musician in afro wig. McKinnies was one of the hardest-working musicians on the scene from 1961 to the mid-1970s, often playing extended runs at clubs such as Jimmy Fuller's Cozy Bar. He would eventually settle in California after years of struggling to make a break from Minnesota.

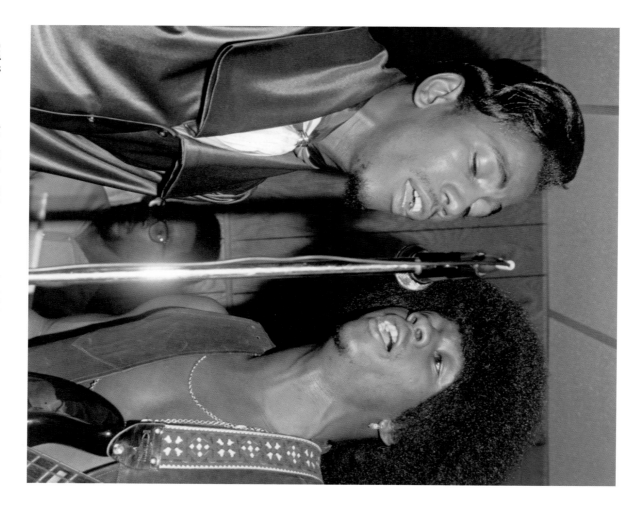

While some white Twin Citizens were mimicking Manhattan's Studio 54 and the glamorous excesses and gender rebelliousness of disco nightlife, Twin Cities funk and soul performed black consciousness in the heart of the whiteness, where dance floors are often integrated thanks to the relative tolerance of black men (especially musicians) taking white women for mates.

Their white bandmates, perhaps, were disaffected middle- and working-class rejects clinging to the funky authenticity that, say, a Mojo Buford carried with him from Mississippi. Meanwhile, disco and a reliance on disc jockeys made life for working musicians difficult. Musicians take note: "Disco is jive, keep music live," proselytizes Morris Wilson, "godfather" of the scene and founder of the Minnesota Minority Musicians Association. Some of the musicians adjusted, finding sonic and sartorial examples in gender misfits Sun Ra, George Clinton, Sly Stone, and Rick James. That adjustment gave rise to something recognizably new but difficult to name except by the place where its forces met.

Like the Harlem Renaissance (1918–29) before it, and the Black Arts Movement (1965–80) that it belonged to, the Minneapolis Sound lasted but a moment. The audio recordings of individual songs don't quite put us there—a then and there that struggled to achieve racial equity offstage. The musicians help tell us what the photographs don't, including the common racial strife that made steady work for a black band difficult to come by.

"I don't like what the club owners are doing to black musicians," said Buford. "It's hell for a black man here trying to make it. I just can't figure it out. If you've got over two blacks in your band, you can't get a gig. That's pitiful." Pensacola-born Maurice McKinnies agreed: "It's hard for black musicians here, that's all."

On the other hand, many younger, more idealistic musicians, like those in the racially mixed Valdons (later known as the Philadelphia Story), worked to look past color in hopes that the universal language of music could bridge racial divisions.

The difference in perspective might be generational. It may also be that, as time went on, white club owners at venues such as the Fox Trap and the Flame began to show more willingness to hire black bands. But even by the 1980s, as Prince and the Time were gaining national attention, complaints similar to Buford's and McKinnies's could still be heard.

Harmony: A bringing together of people and things seemingly disparate. An ensemble hard to name. Disco? Funk? R&B? Soul? Saturday night music made by gospel-reared folks now ambivalent of Sunday mornings? Each iteration warns us about taking single instances for the whole.

Beginning in 1961, the sounds issued during daylight hours from KUXL, black radio out of Golden Valley, Minnesota. Thornton Jones, aka Pharaoh Black, built his own KUXL radio show on years of behind-the-scenes broadcasting expertise and by bringing in advertising dollars from black businesses like King Supermarket, Bob's Brown Hat Shop, Skip's BBQ, and Cozy Bar. Here, he concedes, he succeeded where

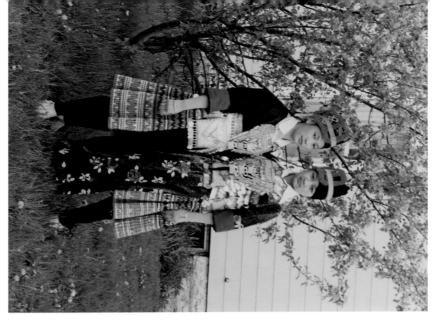

Two women in Hmong clothing

his white predecessor salesmen at KUXL failed: "I would just walk in and sell ads to black business owners who would tell me the white salesmen acted like they were afraid."

By the end of the decade, ten sides would be recorded under the Black & Proud label. By 1976, you could hear Pharaoh Black spinning records on "The People's Station," WMOJ (renamed KMOJ two years later), call letters that purposely intone Swahili, the could-be lingua franca of a liberated African continent: *Umoja*, Unity. Today, KMOJ's tag line is "home of the Minneapolis Sound."

"I wish we could have preserved it," says Jones, who would advertise in black publications like *Insight News* with the slogan "KUXL: Radio for Black People."

Black motive, black spirit.

What was the Minneapolis Sound? It was "pre-Prince," says Anthony Scott. Imagine a Prince Rogers Nelson with afro, a still unglamorous and less ambiguously black Twin Citizen. Pre-Prince in sight and sound only. And space: laminate wood paneling, drop ceilings, mirrors.

In Minnesota, but part of what was happening with black people around the country and, in some cases, the world. Almost forgotten.

• • •

The poorer Jewish families who lived in segregated Sumner housing project buildings across from blacks on the north side eventually headed out for the suburban territory west of Minneapolis. Black families remained close to downtown for a couple of decades before spreading farther north. By the 1990s, immigrant Hmong families dominated the Sumner projects, which were demolished in 1998.

For a time, we arrive at ritual closure of a world that we had imagined for ourselves.

Our Pictureman took up the heroic burden of his nineteenth-century brethren to celebrate commonplace black joy, industriousness, beauty, and talent and serve to move black people from the margins of the mainstream to the center of American life—as if we were always there.

Charles Chamblis died in 1991 at the age of sixty-four. Collectively, the pictures he left behind do something that the work of black photographers have tended to do: they project the vision of the poet who witnesses in tongues that betray the King's English, a twice-told tale of race men and women insisting on making a world outside the kingdom seen.

Look, and listen. ●

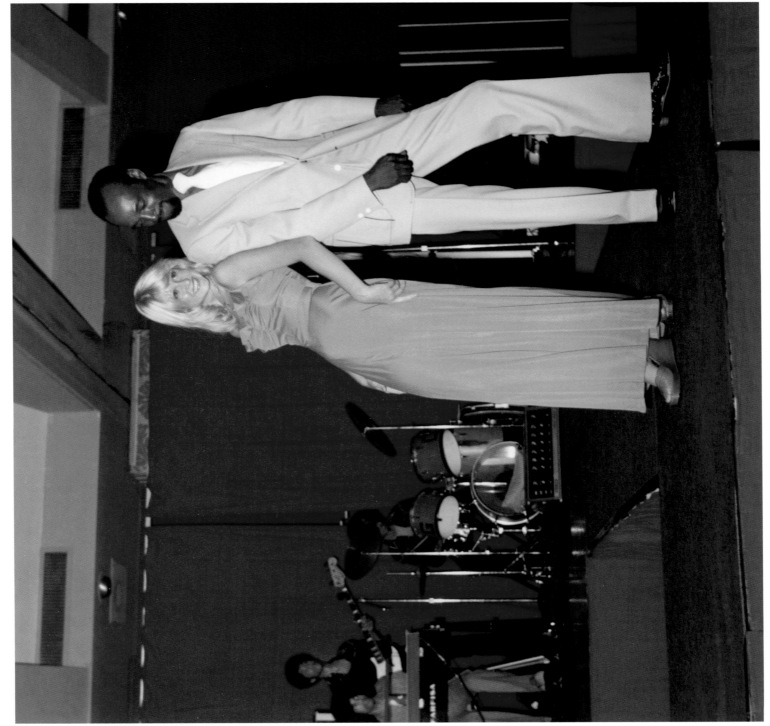

Grand Central supporting a fashion show with Prince Rogers Nelson on keyboards, André Cymone on bass, and Morris Day on drums

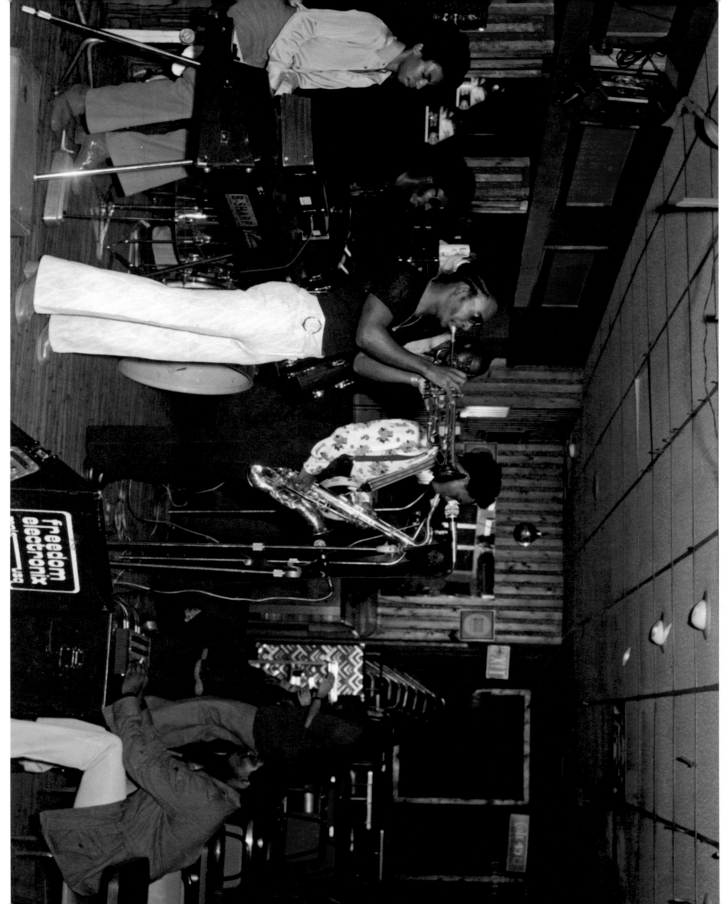

Members of the Family or Lewis Connection checking sound at the Cozy Bar (left to right): Pierre Lewis, Joe Lewis, unidentified trumpet player, Sonny Thompson, unidentified saxophone, Randy Barber (blue jacket on right)

THE MINNEAPOLIS SOUND

AS POPULAR CULTURE after 1968 grew increasingly youthful and unmoored from conventions of the past it became associated with precocious optimism, fresh ideas fed by fully digested old ones and playfulness.

Twin Cities funk and soul of the Cozy Bar did not become the "Minneapolis Sound" of the Fox Trap and the Flame until the late 1970s. According to some, the change came when highly arranged horns were replaced by synthesizers. Others remember horns amid the synthesizers all the while and the sound as characteristically "happy."

"Coming from Minneapolis, both our band and Prince's band didn't use horns," Jimmy Jam Harris—member of the band Flyte Tyme and later producer/songwriter extraordinaire with partner Terry Lewis—recalled in an interview with *Wax Poetics*. "We used synthesizers to play the line of licks that horns would play. I think that has a lot to do with the Minneapolis sound. It also has to do a lot with growing up in Minneapolis, and the idea of combining rock and funk into one kind of thing. It was just a natural thing. We weren't doing what everybody else was doing. We didn't have a direct New York or L.A. or Southern influence; it was a melting pot of a whole bunch of different sounds. If I were to pinpoint it, it was a synth-driven rock sound on the top with a lot of funky bass on the bottom. The architect of the sound was Prince. He had the blueprint for it in his earlier records. He was the architect, and we were the contractors."

During long, drawn-out winter months, basements became labs for experimentation. What fueled the competitive spirit of the times? "It was a small scene," remembers Kym "Mocha" Johnson, singer in the band Myst. "You had to work hard because you knew they were just down the block."

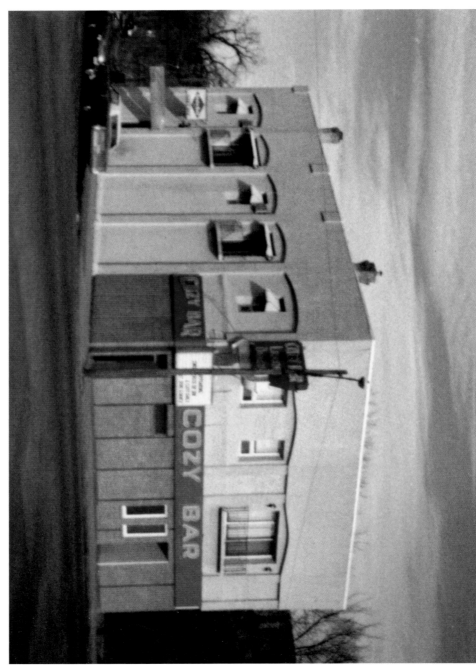

The Cozy Bar and Lounge at
522 Plymouth Avenue

Through summer, because opportunities to perform in the clubs were harder to come by for the teenage musicians in bands like the Family, Grand Central, and Flyte Tyme, they would host "battles of the bands," old-fashioned cutting contests at parks and community centers like South Minneapolis's Phelps and the north side's historic Phyllis Wheatley. Away from the older black social scene of the Cato and Cozy Bar. Gigs that did not require white musicians to be in the bands.

The sound was really about *live*—about the feedback loop between audience and band. At all-night "disco rendezvous" officiated by KUXL radio host Pharaoh Black and a cadre of disc jockeys at the Dyckman Hotel on Eighth Street between Hennepin and Nicollet, bands like Mind and Matter and Myst would wear out the room. While Chamblis was careful to not let setting speak for his subjects, a number

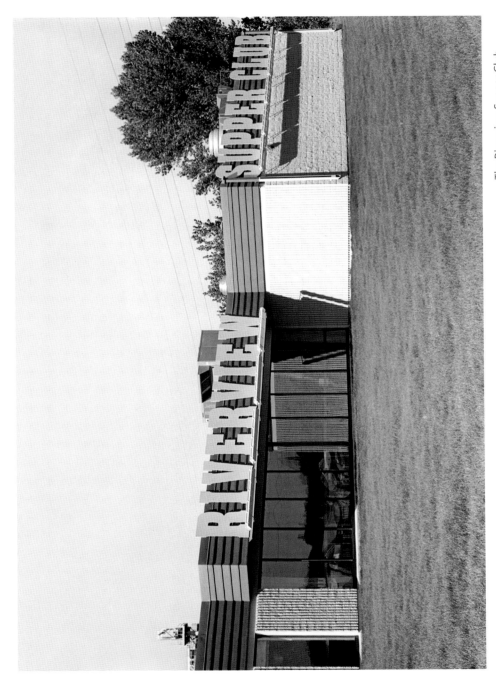

The Riverview Supper Club, 2200 West River Road. Jimmy Fuller opened the Riverview after his Cozy Bar was demolished to make way for Interstate 94.

of Twin Cities music venues provided the necessary platform for presenting three generations of musicians that would develop into the Minneapolis Sound. The turnover rate of clubs willing to present black musicians was rapid, short-lived occupation being the trend in most cases. Chamblis's photos show that location in the city sometimes determined the extent to which the audiences were integrated, especially early on.

Black entrepreneur Jimmy Fuller operated three separate venues in North Minneapolis over the course of thirty-plus years. Both his Regal Tavern (which operated in the mid- to late '60s)—aka the "Bucket of Blood"—and the Cozy Bar (late '60s to late '70s) were central to the development of the more conventional 1960s soul scene, giving musicians like Maurice McKinnies and Willie Walker—the first generation—

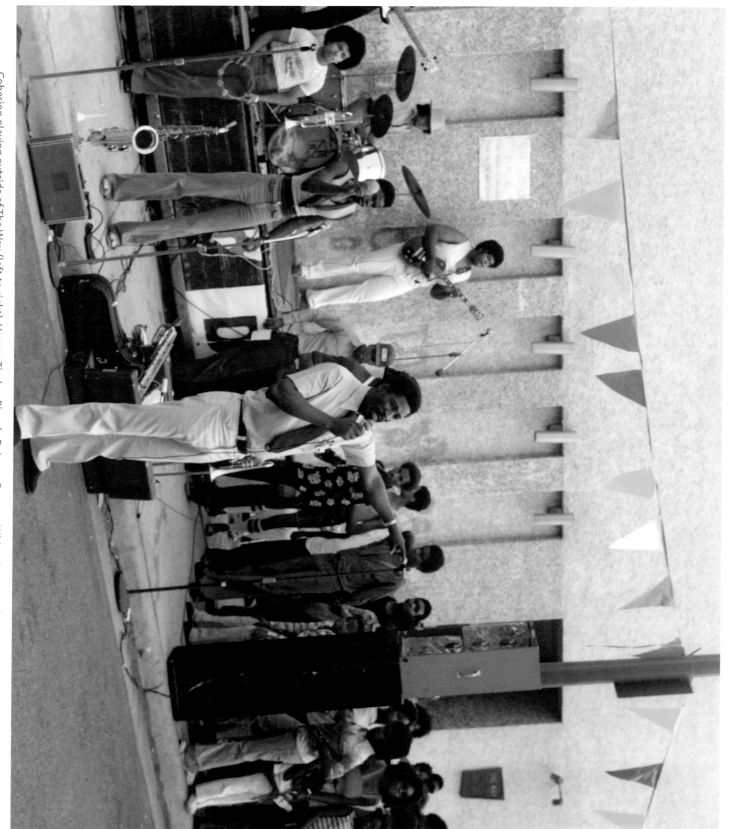

Cohesion playing outside of The Way (left to right): Vernon Tinsley, Ricardo DeJesus, Dwayne White, Ronnie Robins, Douglas Belton

a regular place to perform for their primarily black audiences. One after the other, Regal Tavern and Cozy Bar were demolished to make way for Interstate 94. But, determined to continue, Fuller launched plans for an ambitious new development to sit along the Mississippi River Road: the Riverview Supper Club (1980–2000). The black-owned and -operated *Insight News* was there to detail what many believed were racially motivated efforts by city councilman Dick Miller to refuse Fuller the right to transfer his liquor license from the Cozy to the new property.

Other North Minneapolis locations hosted live music in the '60s, even if it wasn't their main business. Skip Belfrey's Skip's bbq "skipped" around the north side beginning in the early '60s before reaching its final home at 1729 Lyndale Avenue, where it would, for a time, host weekly concerts by the second-generation group Flyte Tyme. For decades, the north side's historic Phyllis Wheatley Community Center, a former settlement house for black families relocating to Minneapolis, has hosted summer festivals that bring in national acts in addition to homegrown favorites. The Way community center, which opened in 1966 and remained until the early 1980s, provided a place for young bands such as Grand Central and Cohesion to rehearse and perform. Staff and community fought off attempts to undermine and shut down the establishment throughout its life, and it was blamed for helping to incite the 1967 disturbance on Plymouth Avenue. The Capri Theater, built in 1927 as the Paradise Theater and renamed the Capri in 1967, was primarily a movie house but may be best known as the venue where Prince played his first solo show, in 1979. In the late '60s and '70s, it hosted talent-show competitions featuring Kentucky transplants the Strivers as the house band and one-off concerts by musicians such as Willie Walker.

But the sound did not limit itself to the north side, even if it appears that that's where it did most of its growing up.

At 3949 Fourth Avenue South, the Nacirema was a private club located in the heart of South Minneapolis's black community, just blocks from the Minneapolis Urban League headquarters. Nacirema is the backward spelling of "American" and an inside joke among social scientists. As the name of a black nightclub, it ironically suggests that black Twin Citizens are an exotic "other" compared to their white counterparts.

At 1523 Nicollet Avenue South, just beyond downtown, the Flame (1951–78) opened its doors to black jazz musicians like Percy Hughes before many of the soul and R&B singers relocated from their southern homes. By the 1970s the Flame operated as a country and western bar with a "Disco Soul" room in back.

White-owned venues downtown like King Solomon's Mines (1966–69), located

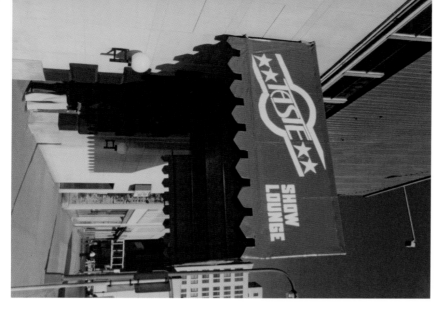
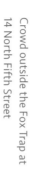

Crowd outside the Fox Trap at
14 North Fifth Street

in Minneapolis's first skyscraper, the Foshay Tower, welcomed a mostly black clientele in search of the early soul and R&B sound. After a short while, it become targeted by the police and was shut down.

Downtown venues of the 1970s provided an occasion for mixed clientele and might be thought of as the major incubators for the crossover aesthetic of the new "Minneapolis Sounds" that second-generation musicians like Mind and Matter and 94 East brought out from their basements.

"Jimmy Jam" Harris, Thornton "Pharaoh Black" Jones, Kyle Ray, and others would DJ nights at the Fox Trap and the Taste Show Lounge during the heyday of the sound. When those venues had closed shop by the mid-1980s, Riverview tried to fill the vacuum they left behind until it closed in 2000.

Third-generation musician "Mocha" Johnson remembers that, at first, black female singers were popular given their scarcity, but as white bands began to master R&B, things began to change. She remembers seeing a band fronted by a white woman singer perform the music of Chaka Khan. "I heard them and I thought, 'We're in trouble. Why would anybody want black musicians?'"

Without bitterness (if it must be said) but with a profound recognition of the circumstances facing a black musician in the Twin Cities, "Mocha" acknowledges that these white musicians "raise their children on our music."

But for a time, it was different. •

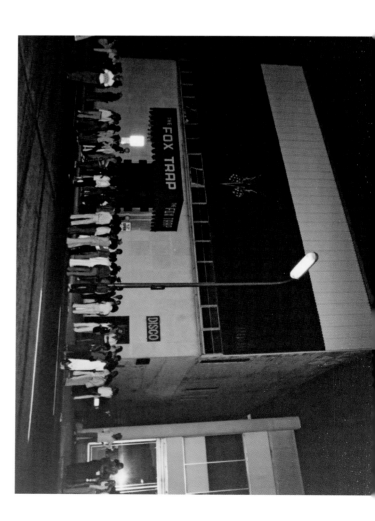

The Taste Show Lounge, which replaced the short-lived Fox Trap at 14 North Fifth Street in downtown Minneapolis

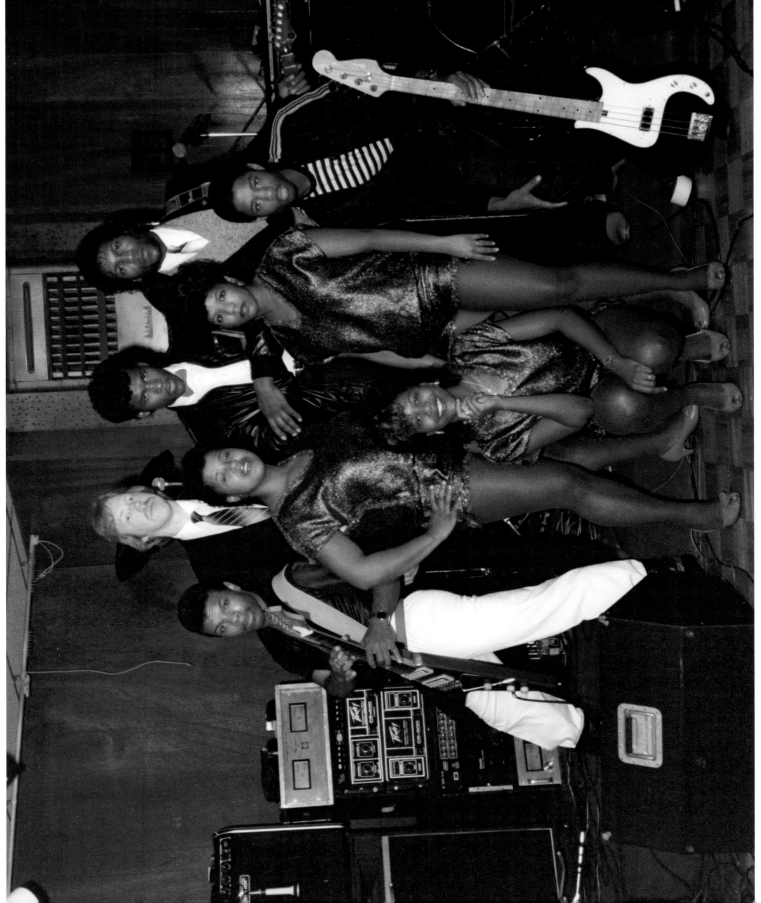

Myst, with the band Network, at the Flame. Myst was (front, left to right): Kathleen Johnson, Kym "Mocha" Johnson, and Rhonda Johnson.

The Philadelphia Story, known earlier as the Valdons (left to right): Maurice Young, Clifton Curtis, Monroe Wright, Bill Clark

Free System (left to right): George Neal, unidentified trumpet player, Wilbur Cole, Thedro Soluki, unidentified bass player, Maurice McKinnies front and center in afro wig

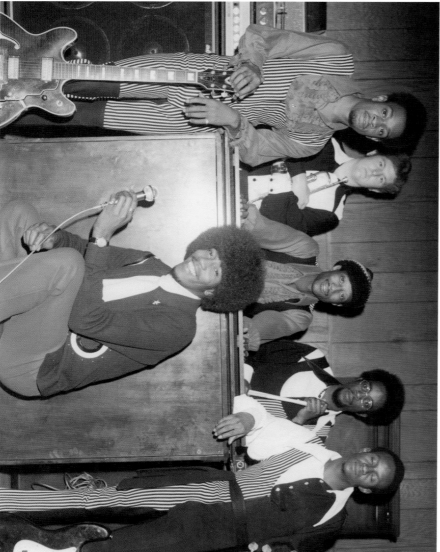

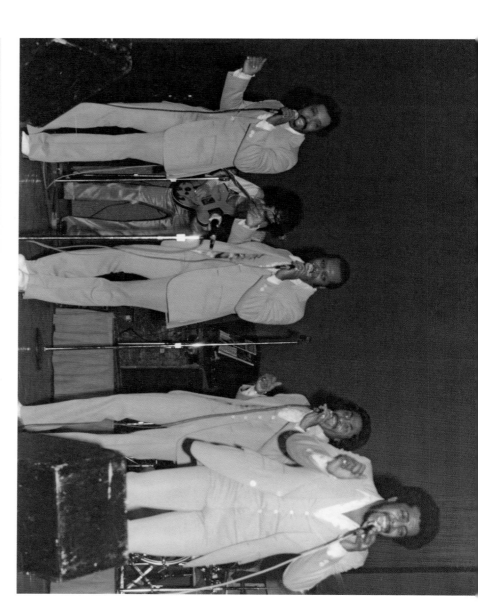

33

Solid on Down: (back row, left to right) Ramond Parker, George Neal, André Broadnax; (front row, left to right) Mark Parker, Jody Johnson, Willie Walker, Wilbur Nichols

The Philadelphia Story at Dick's Jet-A-Way Club

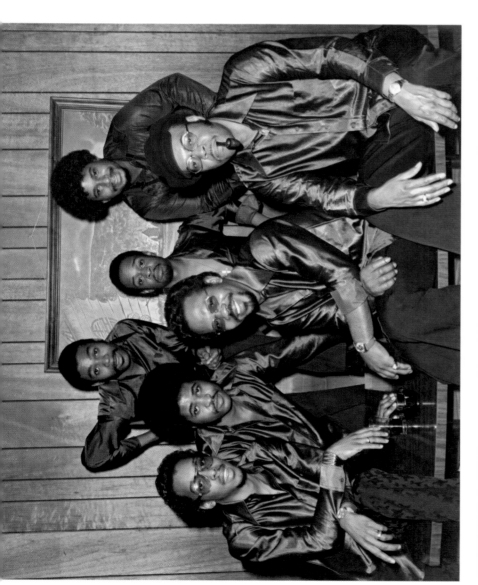

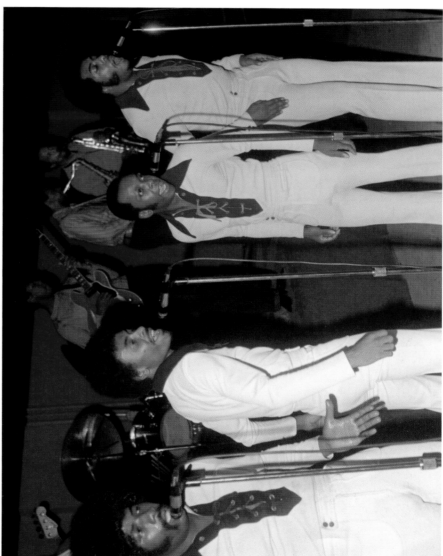

Solid on Down, featuring "Wee" Willie Walker. Of the generation that preceded Prince, the Sam Cooke-inspired singer Willie Walker stood out, making it big as a Twin Cities based-musician. Now in his seventies, he travels the world playing blues and soul festivals.

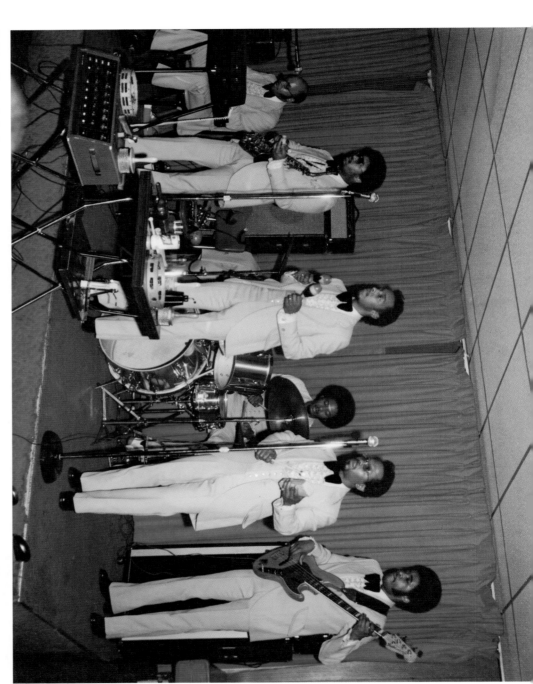

Morris Wilson with legendary singer Bobby "Blue" Bland and others on a tour

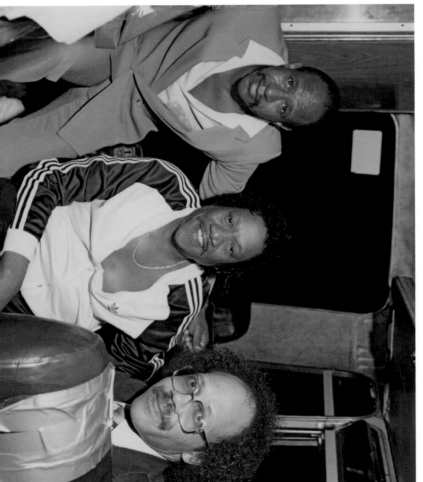

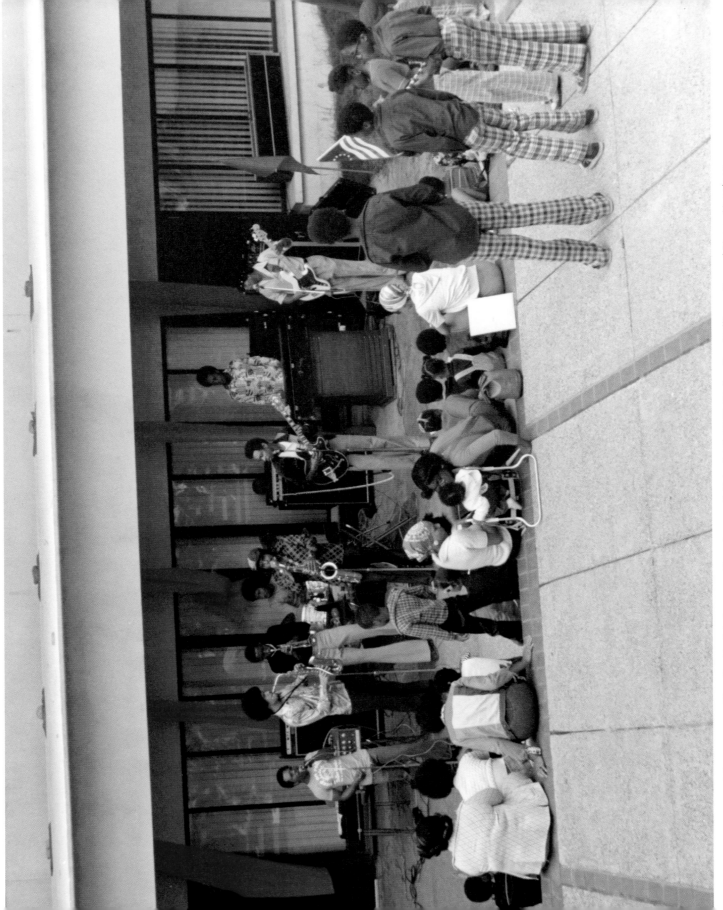

Solid on Down at Pilot City Health Center on Penn Avenue (left to right): Willie Walker, Troy Williams, Howard Bivens, Napoleon Jones, George Neal, Danny McGee, unidentified keyboardist, Joe Ray

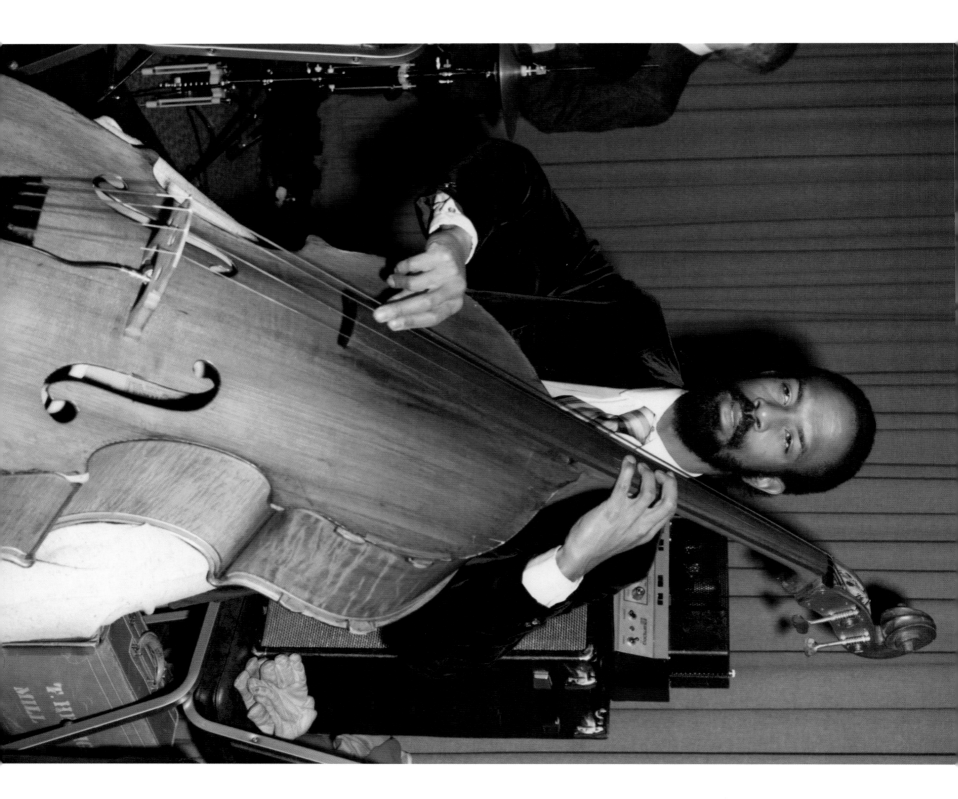

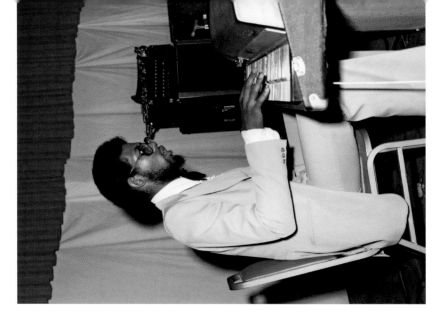

Keyboardist Tom West, who continues to perform jazz throughout the Twin Cities

Opposite page: Bassist Jay Young remains central to the funk, pop, and soul music scene in Minneapolis

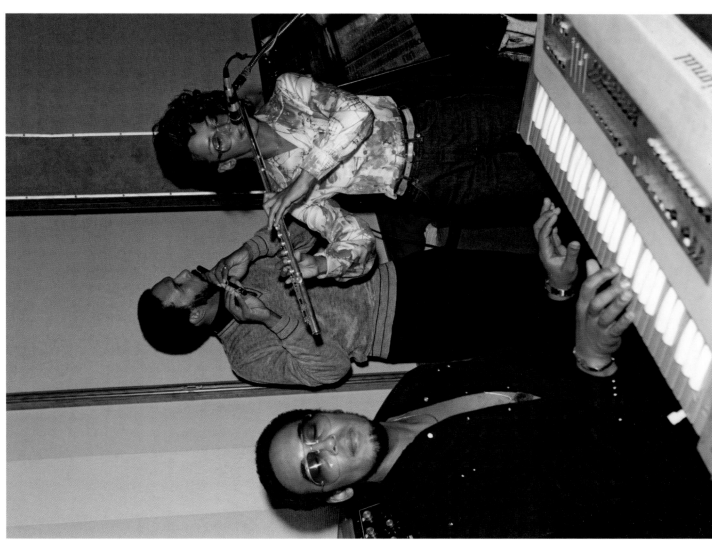

Master of the B-3 organ Billy Holloman with Frank Wharton on piccolo and Nita Hicks on flute

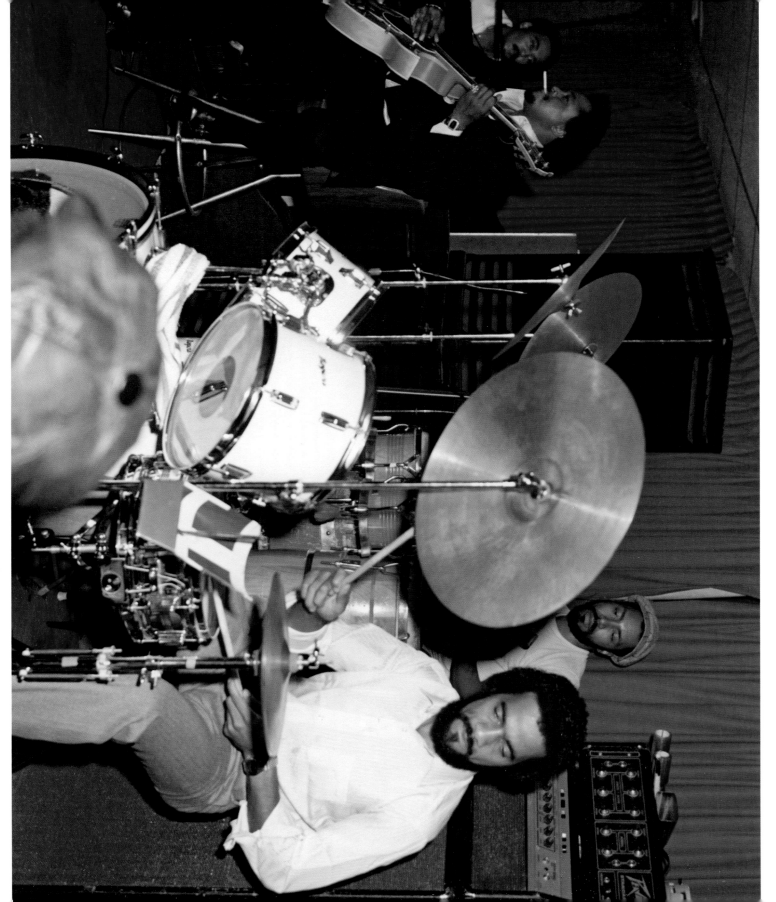

Jam session (left to right): Billy Holloman, Michael Powers, Harold Boudreaux, Bobby Lyle

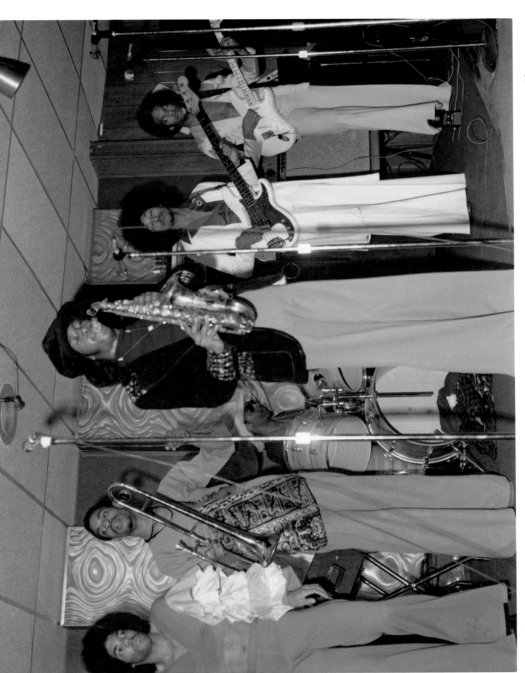

Above: Unidentified musicians

Far left: Singer William Valentine and Bobby Lyle on keyboards

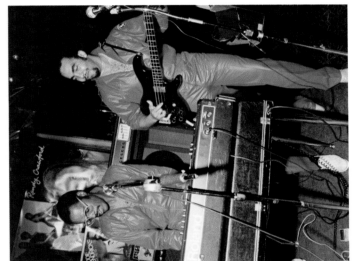

Left: Keyboardist Sonny Williams and bassist Layne Bellamy at the Taste Show Lounge

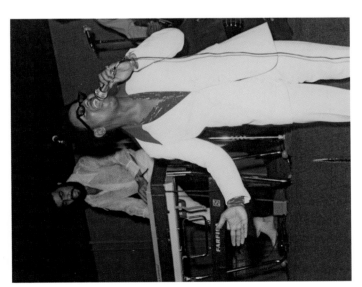

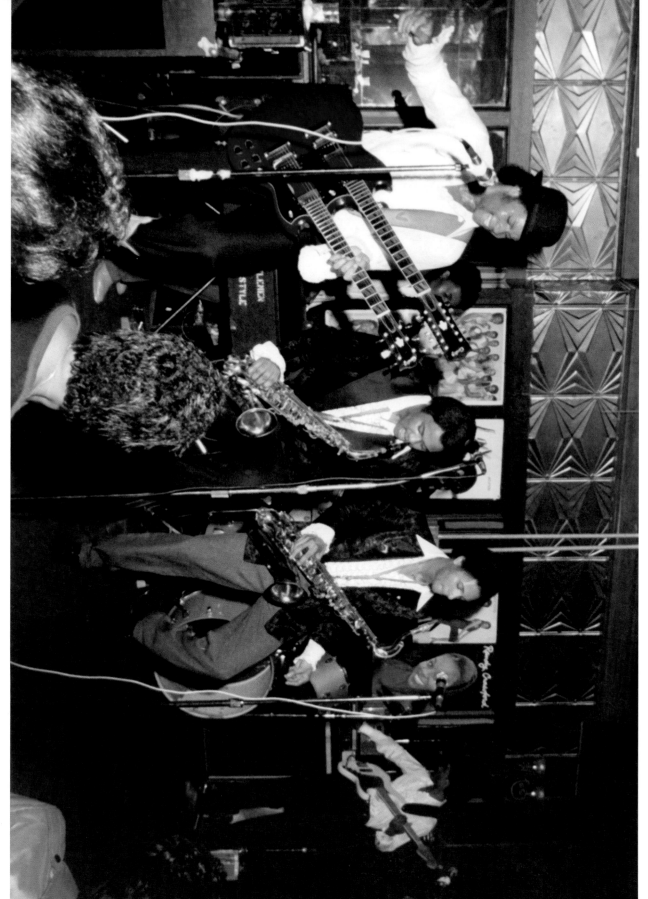

The Style Band at the Taste Show Lounge. Formerly the Gentlemen, the group renamed themselves the Gentlemen of Style and, finally, the Style Band after noting that "the Gentlemen" was already spoken for on the local scene.

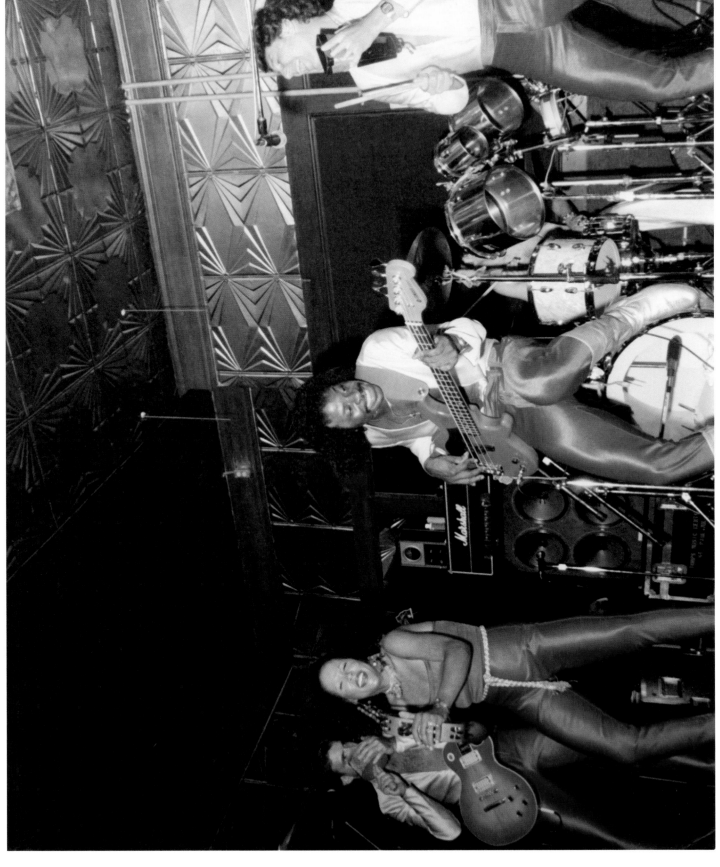

Runway at the Taste Show Lounge, featuring Paul Johnson on bass (center) and Lori Anderson (second from left)

42

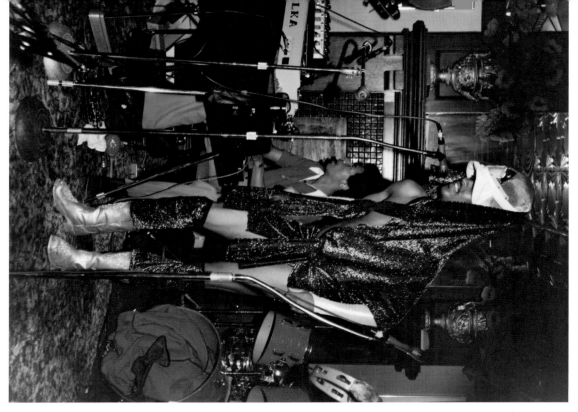

Right: Good Vibrations at the Flame

David "Batman" Eiland singing with Pierre Lewis on piano

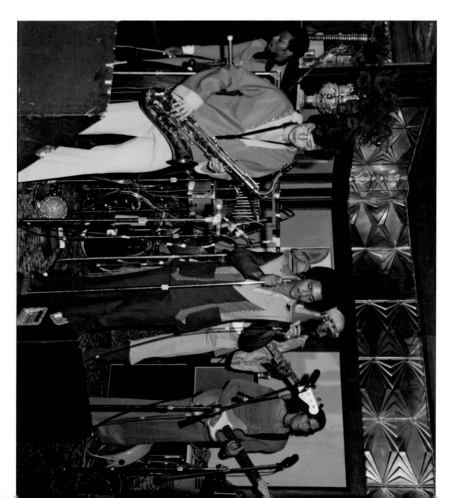

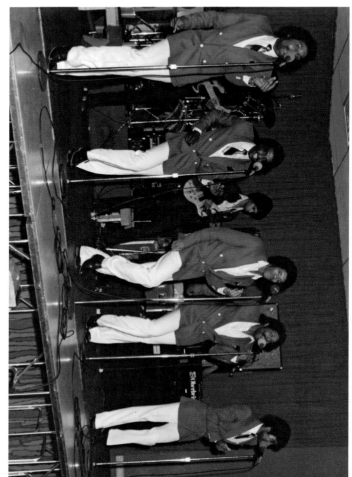

The Gentlemen performing at the Riverview Super Club. The Gentlemen are among the Twin Cities bands whose recordings have not been recovered—assuming they ever recorded at all.

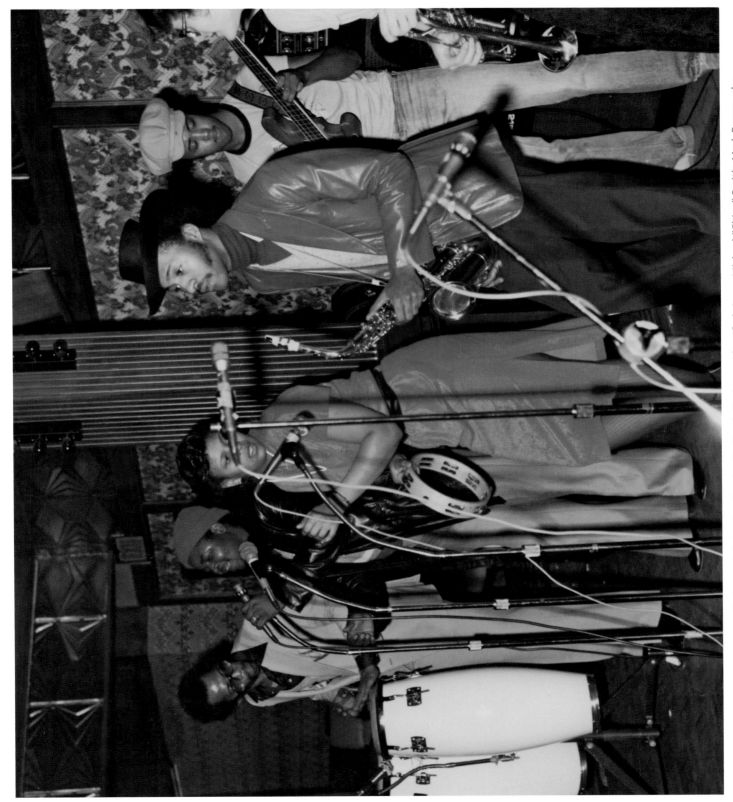

Musicians at the Flame (left to right): Booker Arradondo, Randy Barber, unidentified singer, Michael "Chico" Smith, Mark Brown, aka Brown Mark of Prince and the Revolution

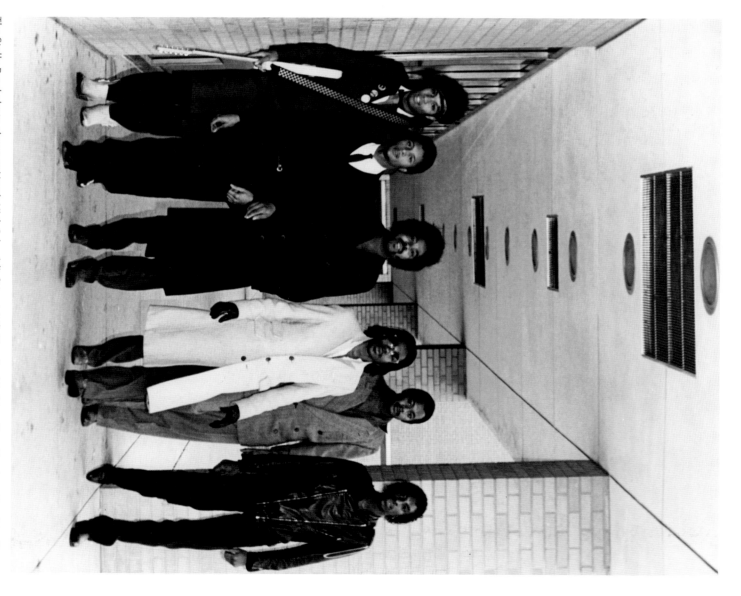

The Stylle Band photo shoot at North High School (left to right): Maurice Marbles, Greg Cauthen, Daryl Wells, Billy Hart, Byron Walker, Willie Roberts

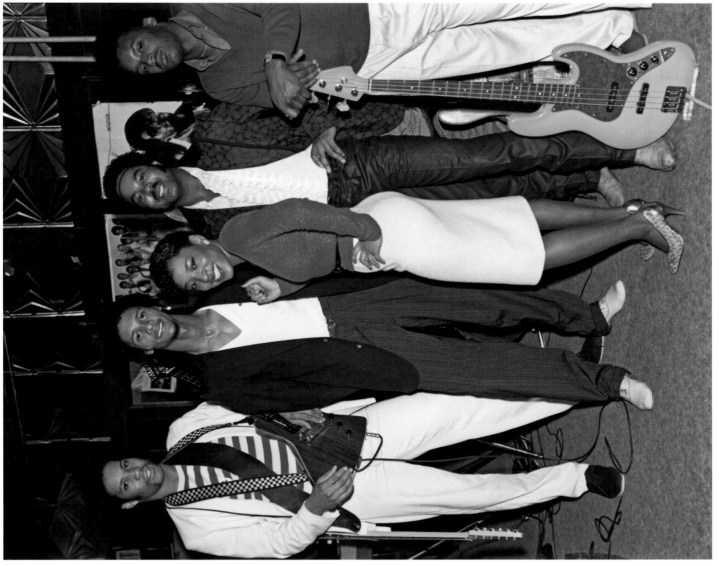

Members of the Stylle Band and the Girls at the Flame (left to right): Craig "Screamer" Powell, Greg Cauthen, Germaine Brooks, Daryl Wells, Jerry Hubbard

Members of the Girls posing with friends at the Taste
Show Lounge

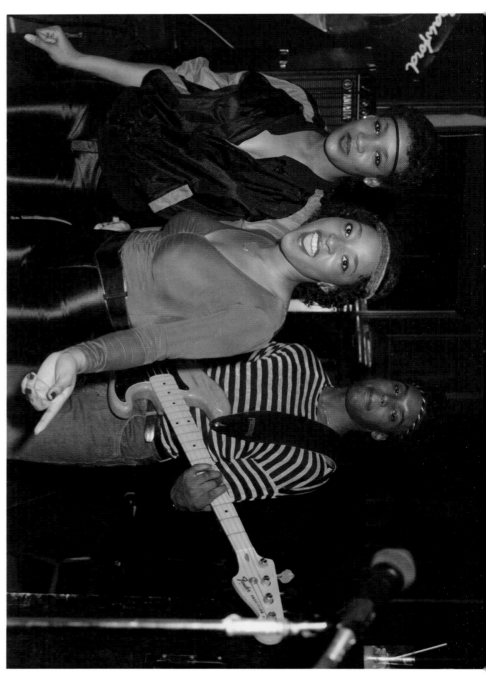

Sheila Rankin and Germaine Brooks at the Flame,
with Jerry Hubbard on bass. Under the supervision of
André Cymone, Rankin and Brooks were later joined
by singer Doris Ann Rhodes to form the Girls.

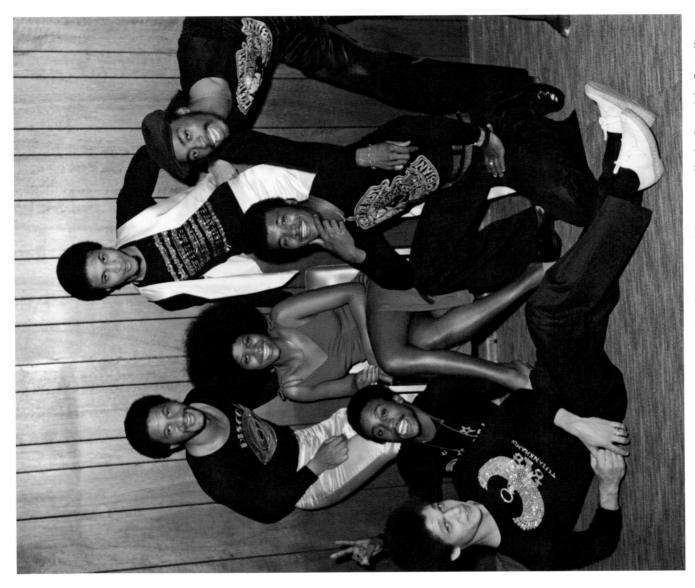

Quiet Storm: Robert Martin, Maurice Stevenson, Donald Berry, Hank Stevenson, Charles Berry, John Berry, Kym "Mocha" Johnson (center)

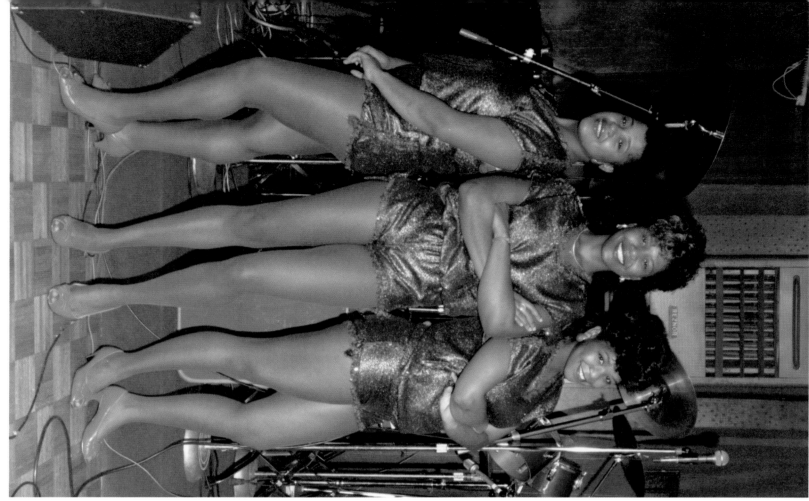

Myst at the Flame (left to right): Kathleen Johnson, Kym "Mocha" Johnson, Rhonda Johnson

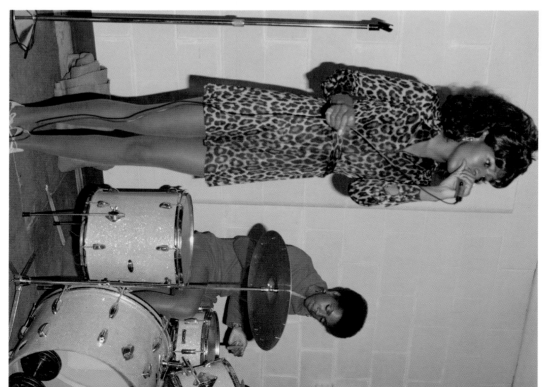

Unidentified musicians

Opposite page: Flyte Tyme dressed as Parliament-Funkadelic for Halloween (clockwise from top left): David Eiland, Anton Johnson, Garry "Jellybean" Johnson, David Wright, Cynthia Johnson, James "Chipmunk" Anderson, Terry Lewis (center)

Flyte Tyme with Alexander O'Neal

Right: Cynthia Johnson, singer of the iconic song "Funkytown"

Opposite page: Cynthia Johnson (singing) and Jellybean Johnson (drums) at the Elks Lodge

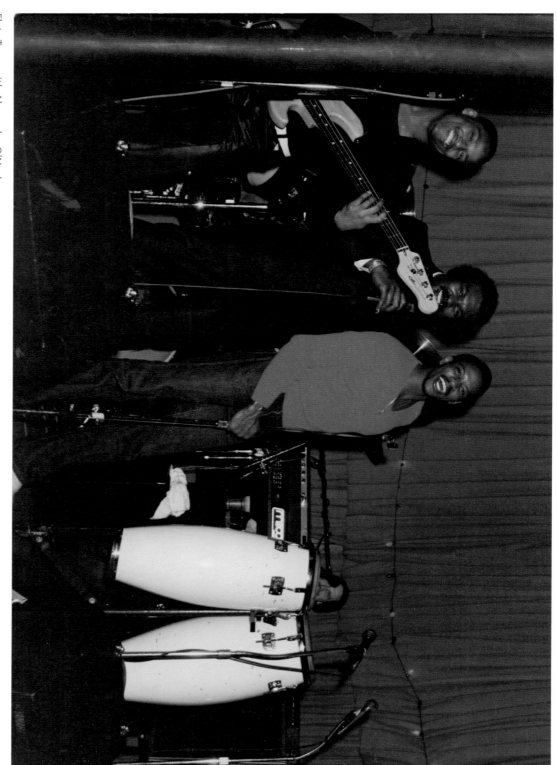

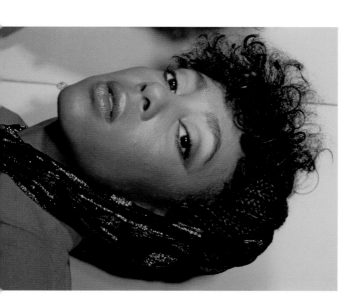

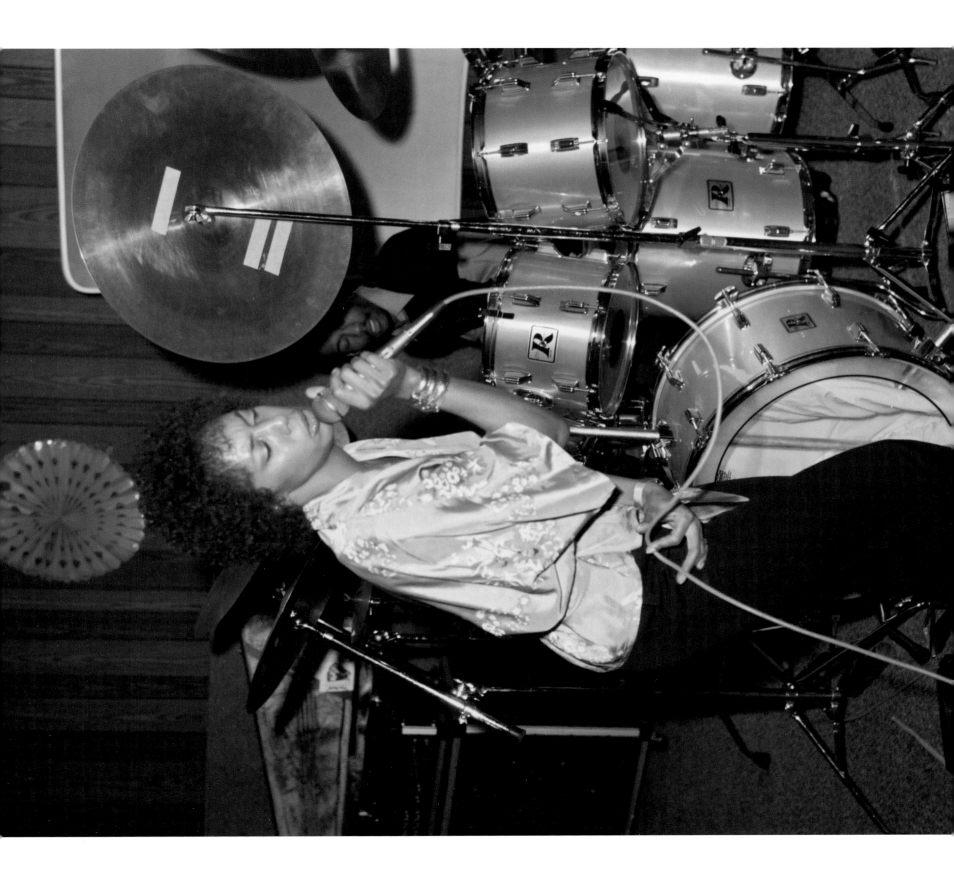

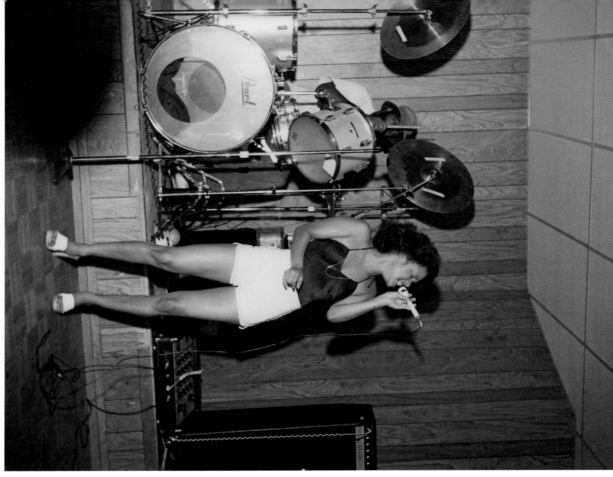

Sue Ann Carwell with Donald Thomas on drums

Right: Linda Renee Anderson of Champagne

Opposite page: Champagne, formerly Grand Central (left to right): Morris Day, William Doughty, Linda Renee Anderson, André Cymone

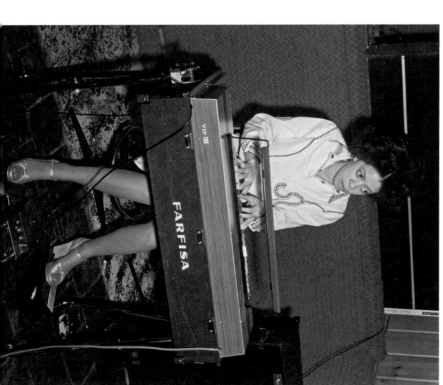

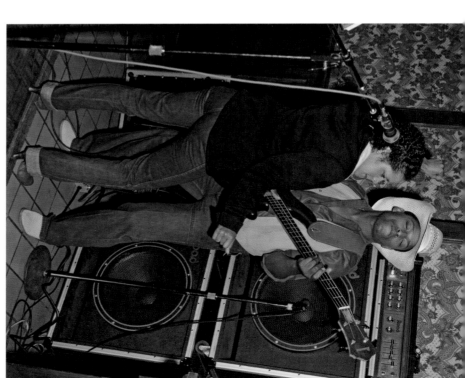

Terry Lewis and Sue Ann Carwell

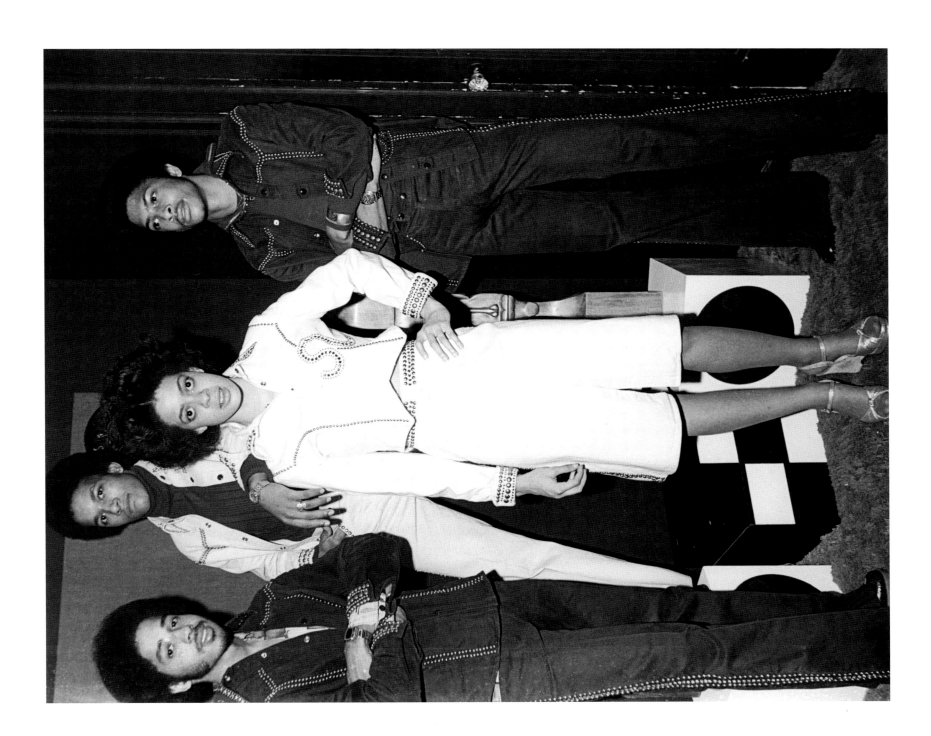

Jimmy Jam Harris at the Taste
Show Lounge

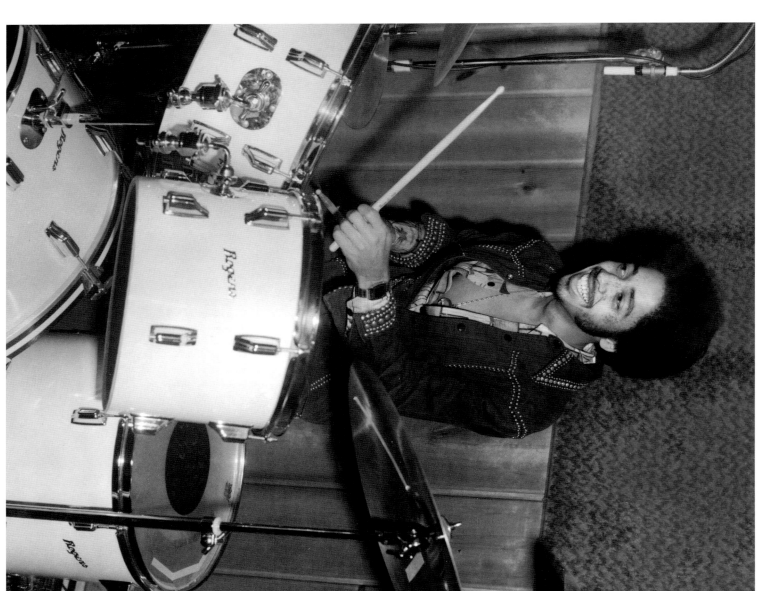

Morris Day, who later became famous as leader of the Time

Jellybean Johnson, later the drummer for the Time

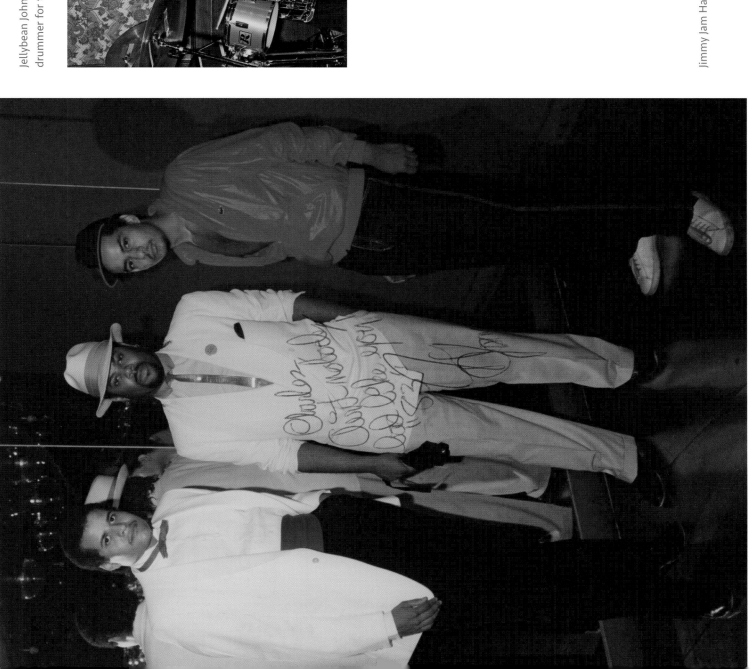

Jimmy Jam Harris and friends

Prince performing at the Phyllis Wheatley Fest following the remarkable success of his early recordings for Warner Bros. Records

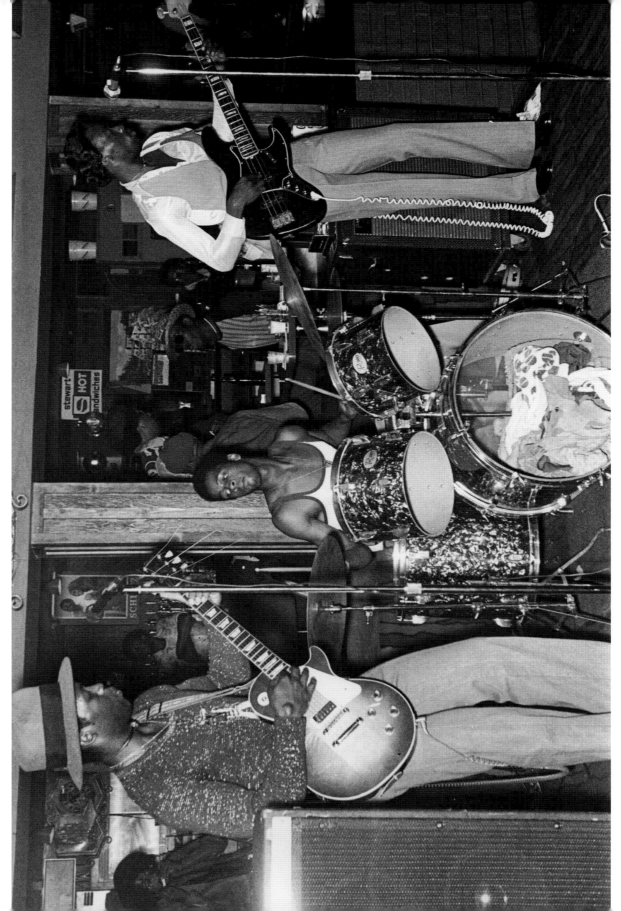

Members of the Family or Lewis Connection performing at Cozy Bar

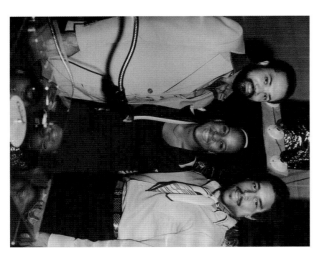

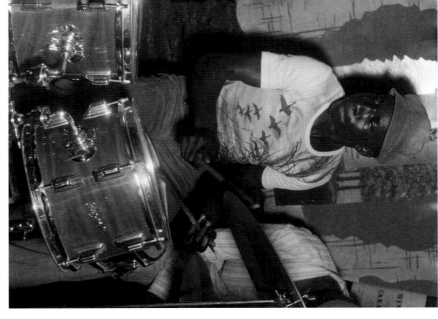

Dale Alexander, drummer for 94 East

Stephanie Fleming and Pierre Lewis dancing at the Taste Show Lounge

Left: Thornton Jones, known as "Pharaoh Black" (left), unknown woman, and Kyle Ray. Ray, a DJ at KMOJ and the Fox Trap, was murdered on June 24, 1980. "He was like a little brother to me," said Jones.

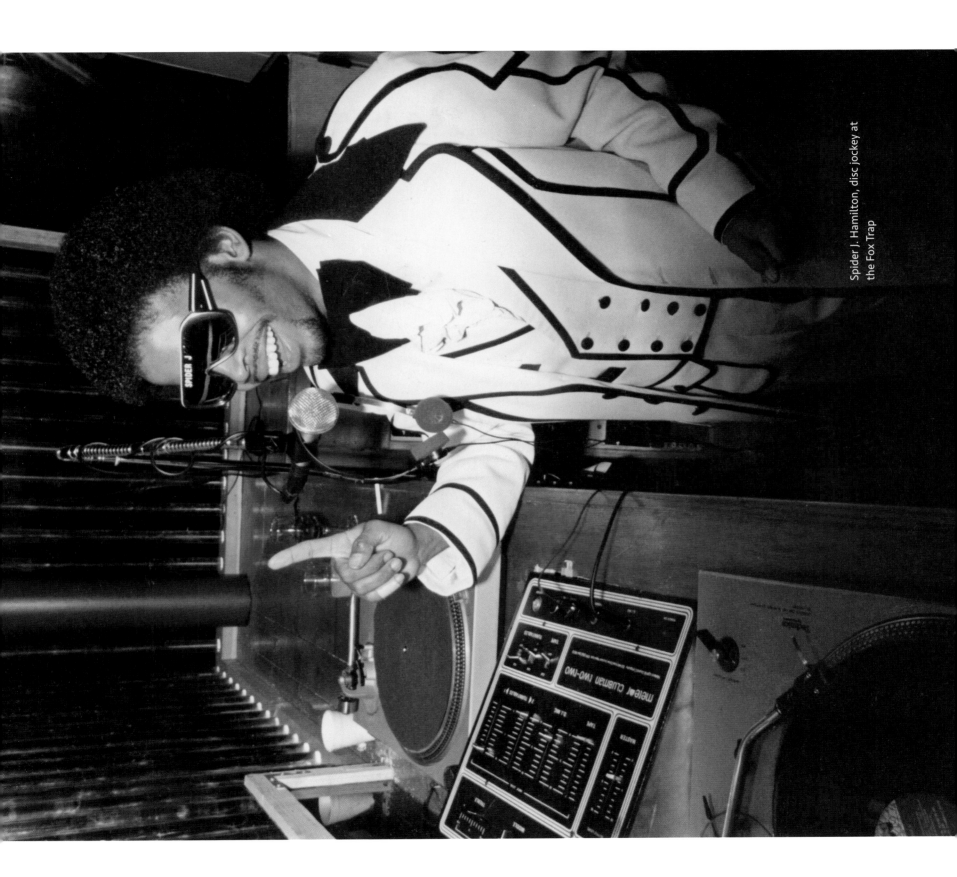

Spider J. Hamilton, disc jockey at the Fox Trap

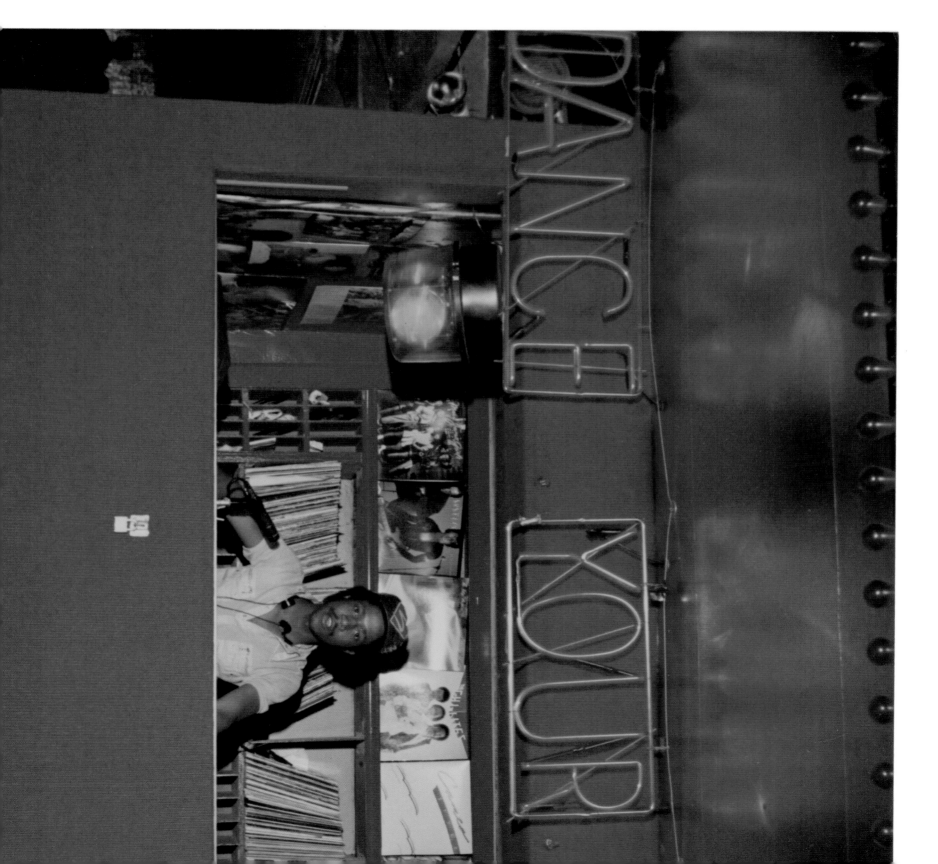

Dance contestants feeling the disco fever at the Taste Show Lounge

Disc jockeys at the Bowery Club, Fifteenth Street and Nicollet Avenue

Left: Disc jockey Steve Holbrook in the booth at the Taste Show Lounge

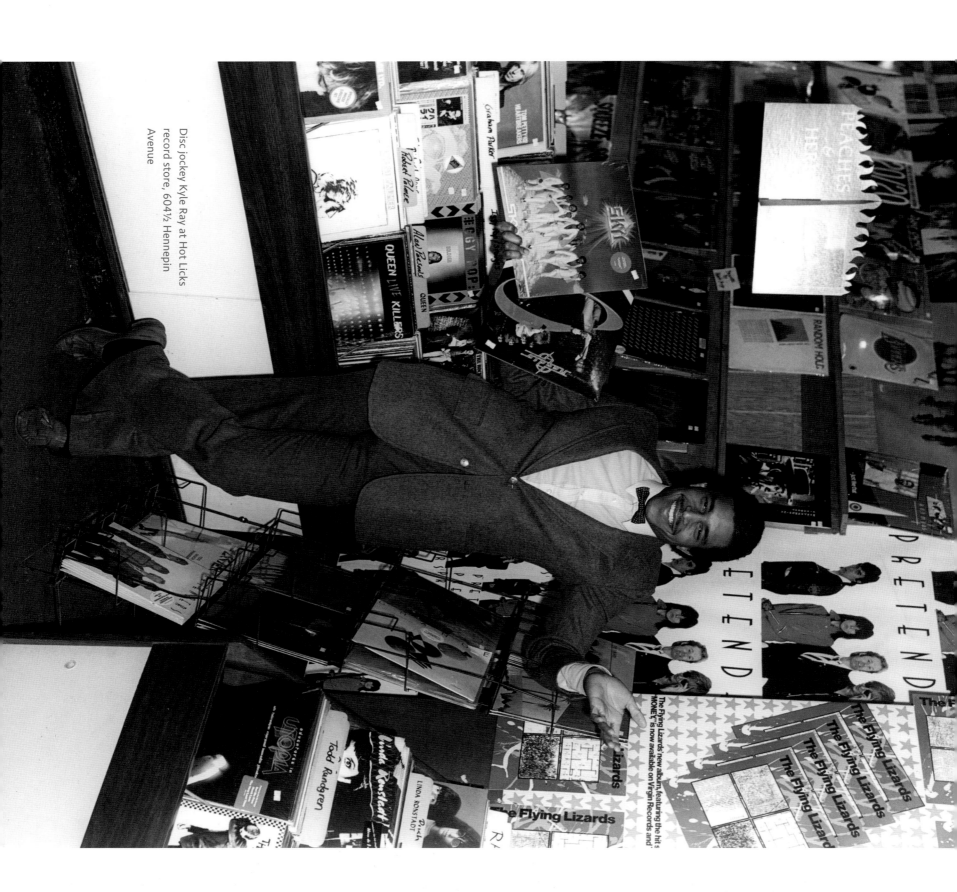

Disc jockey Kyle Ray at Hot Licks record store, 604½ Hennepin Avenue

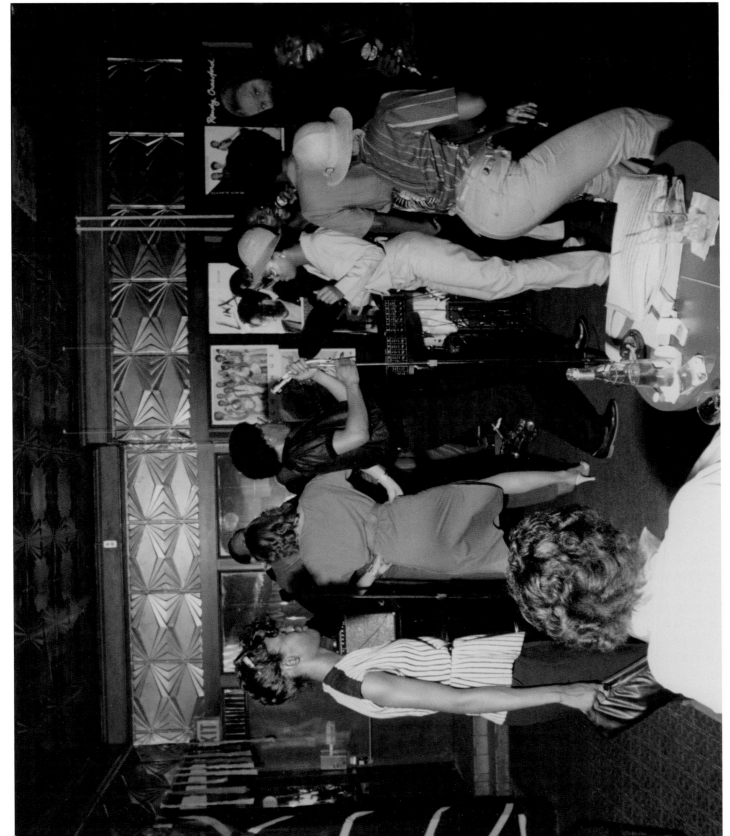

Unidentified musicians with dancers at the Flame. Speaking on the difference between live performance versus spinning recorded music as a DJ, Thornton Jones remembers "the music got funkier the more the audience got into it."

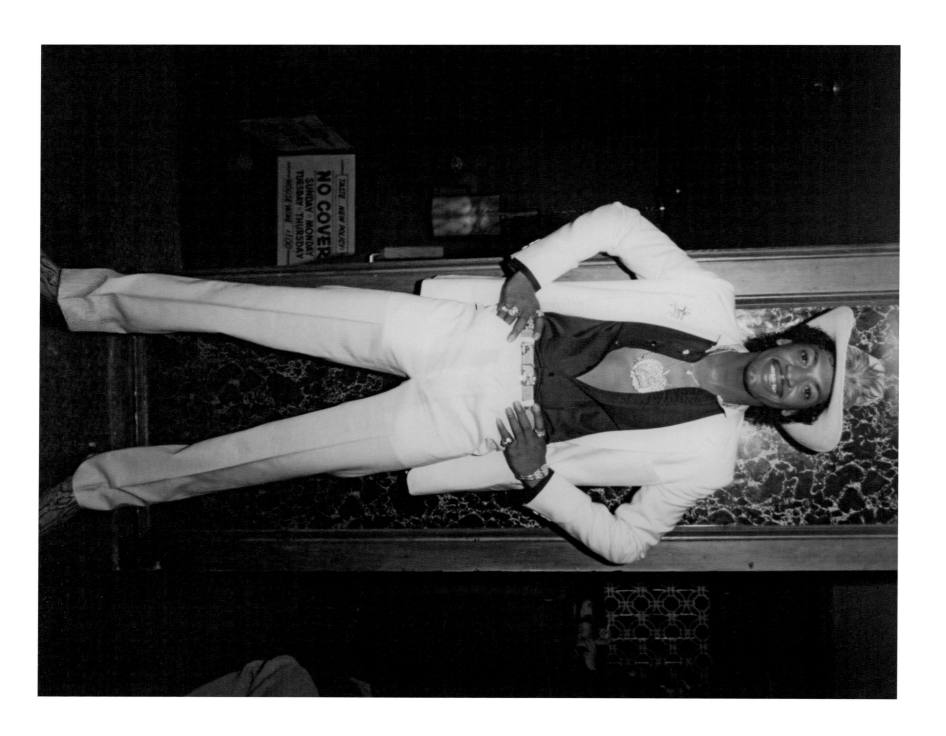

BLACK BEAUTIES

Style is referential. It points to places and identities.

—Maxine Leeds Craig

MAXINE LEEDS CRAIG, author of *Ain't I a Beauty Queen? Black Women, Beauty, and the Politics of Race*, identifies two motives for expressions of black style: respect and pleasure. Yet, for the youth headed out for a night of pleasure after a Sunday afternoon spent outside the old bathhouse at Lake Calhoun, "you couldn't just come out with your regular clothes on." Proud "race man" and musician Anthony Scott lived a life that swung between a career as a master's-degreed social service professional and a talented bass player with Prophets of Peace and Sounds of Blackness. Reflecting on a longtime understanding among black Americans about the relationship between fashion and self pride, Scott remembered how his father Walter Scott bought personally tailored suits from Louis "Scotty" Piper's famous shop on Forty-Seventh Street in south Chicago. Piper is known to have outfitted musicians like the Ink Spots, Nat "King" Cole, Count Basie, Lou Rawls, and the infamous former heavyweight champion boxer Jack Johnson, known for his outlandishness and signature black dandy attire.

Youth culture as popular culture, however, tends to privilege pleasure over respect, for in its immediacy it can't spare a moment to consider how the gaze of the other might affect family and future. Also, Maxine Leeds Craig reminds us, for young people like those of the Twin Cities scene, the past—the South—is thought "far behind and contrary to whatever is most contemporary in collective and individual expression."

Opposite page: Jerry Morgan dressed up for a night out at the Taste Show Lounge

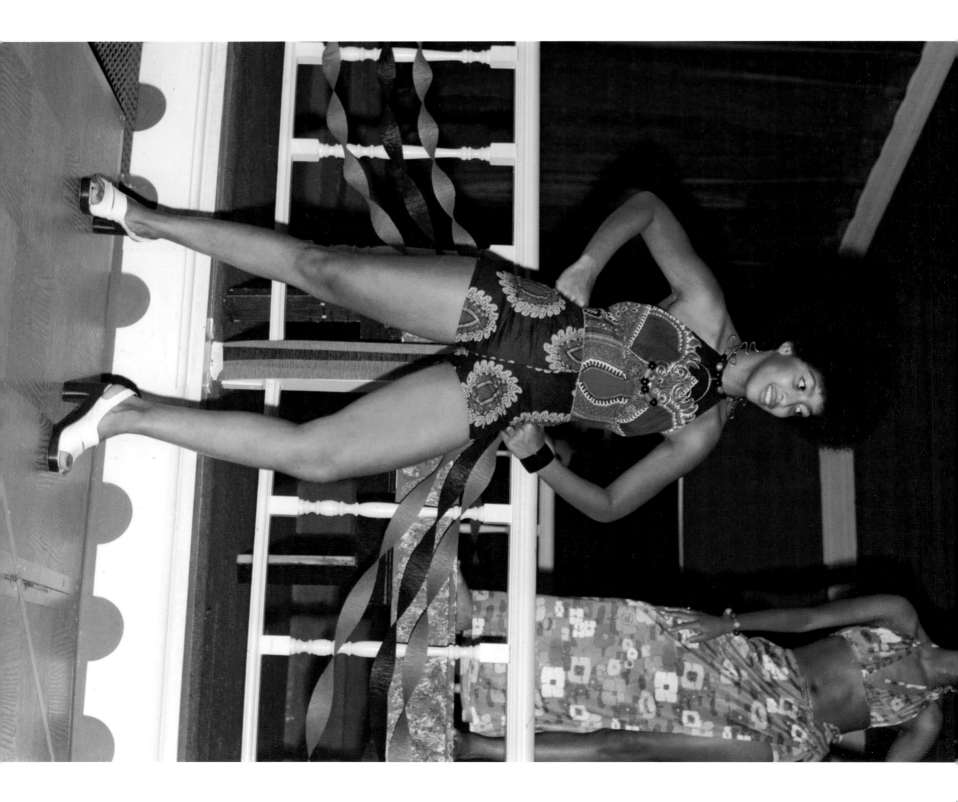

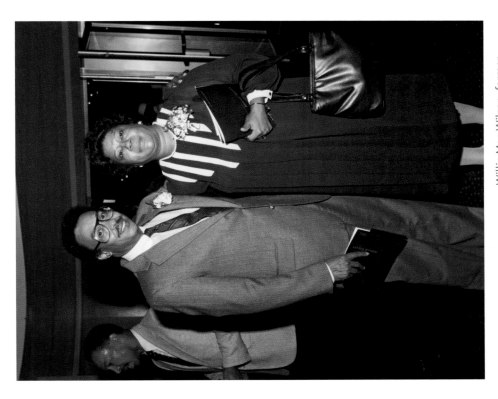

Willie Mae Wilson, former executive director of the St. Paul Urban League, posed with her husband, Bill Wilson, at a league event given in her honor

Opposite page: Patricia Anderson modeling in paisley halter top, shorts, and afro. Note also the streamers echoing the colors of the pan-African flag.

Offstage, alongside images of older black professionals in business attire and leisure suits—outside the realm of mainstream respectability—are a variety of styles indicative of the youth culture of the moment, styles which black tastemakers like mass-market publications *Ebony* and *Jet* and television shows like *Soul Train* put into circulation. Flagg Bros, Eleganza, and John Hardy couture was available at Shoe Fly, Brown's Clothing Store, and Keiffer's House of Style.

The impact that "new black media" publications like *Essence, Ebony,* and *Jet* had on the beauty standards circulating in black communities across the country is, without a doubt, significant—particularly through the aegis of the first lady of Johnson Publications, Eunice Johnson, and the Ebony Fashion Fair. As far back as the 1950s, *Ebony* has hosted a bonanza featuring black runway models displaying the work of top European fashion designers. The print publication allowed the moment to trickle down to middle- and working-class black women across the country who did not have access to the live event.

But the new black media also followed the lead that a conscious generation of iconic soul stylists such as Angela Davis provided. In her book *Liberated Threads: Black Women, Style, and the Global Politics of Soul,* Tanisha C. Ford writes, "Davis did not ignore the fact that natural hairstyles and African-inspired clothing were fashionable in the Black Power era. She contextualized her style within a longer international history in which Africana women incorporated the concept of 'styling out,' or dressing fashionably, into the quest for black freedom and gender equality."

Prior to this revolution, both men and women wore processed hair, an attempt at the refinement that middle-class blacks had borrowed from the upper classes, who had borrowed much from white standards of beauty. In the images captured by Chamblis, both men and women wear their hair naturally, or exaggerate for style the texture of unprocessed black African hair.

Working-class black women on the Twin Cities scene in the 1960s, '70s, and '80s lived in a world that had shifted from the modesty of middle-class "colored women's clubs" and Madam C. J. Walker's beauty products—among them hair straightener and skin "whitener." In this younger world, black women, with more frequency and determination, used fashion to express sexuality, individuality, and blackness in positive terms. The scene is one of profound "cultural revolution"—in particular, the Civil Rights Movement's turn to Black Power and the heyday of the sexual revolution.

Still, following the bold heading "His Is Hers," the introduction to a fashion photo feature in the May 1971 issue of *Ebony* reads:

Gettin' it together means sharing things with your man like his laughter, his worries, and his own special way of "doin' a thing," as brother Isaac Hayes puts it. In the world of fashion, the black man has traditionally had his own way of "doin' a thing," and even when the rest of the male world went conservative, the black man retained a distinguishing flair and excitement in his dress. These exciting his and hers fashions from Jerry Magnin's hip new Beverly Hills men's boutique will provide the means for the black woman to also share her man's taste in clothes.

• • •

"It was a man's world," says Kym "Mocha" Johnson, who was nicknamed for her complexion.

Black male authenticity is often imagined through a feedback loop of styles associated with the black church (think a permed and double-breasted James Brown), or the 1970s urban pimp dandy anti-hero of blaxploitation films that might have screened at the Capri Theater, like *The Mack*. Gordon Parks's black stud detective hero in *Shaft* and drug kingpin in *Super Fly* also appear to have been heroes to many. And, as if to heighten the sense of black masculinity where vision is unfit to, soundtracks for the latter films would be provided by black masculine funk and soul composers Willie Hutch, Curtis Mayfield, and Isaac Hayes.

Onstage we see matching leisure suits familiar with uniform, Motown-era rhythm and blues bands and zoot-suited sharps of old. Apple cap–donning brothers from around the way. Italianate harlequin costumes. Eventually we are met with psychedelic futurism, which often looks like the black imagination's desire to be unmoored from between militant and macho cultural nationalism and those resigned to assimilate.

By the 1980s that futurism was dialed down to leather, pleated slacks, and a new wave penchant for slim-fitting suits, workout clothes, and animal print. Clothes

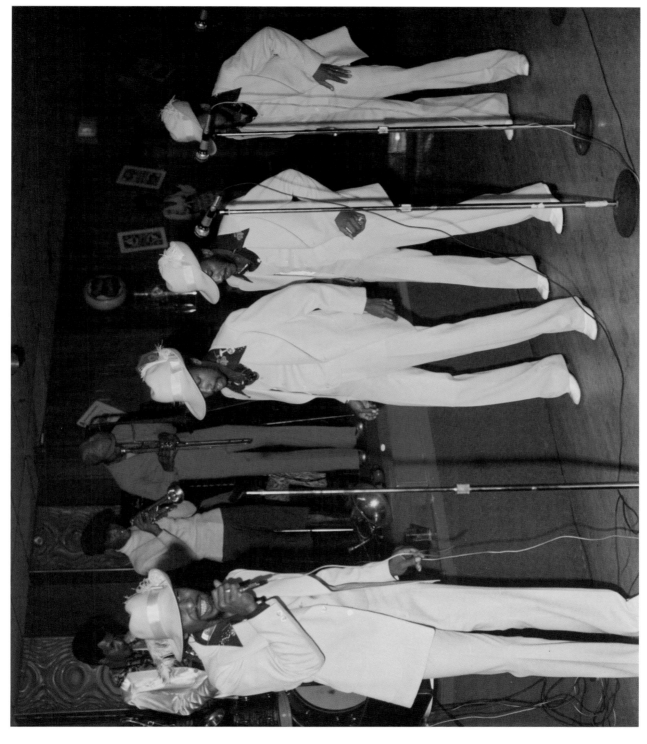

Motown's looking a little pimpish with these unidentified soul crooners in matching yellow suits and fedoras

Keyboardist Wilbur Cole of the Exciters, Band of Thieves, and Free System is '70s "black macho" personified. Cole continues to play regularly.

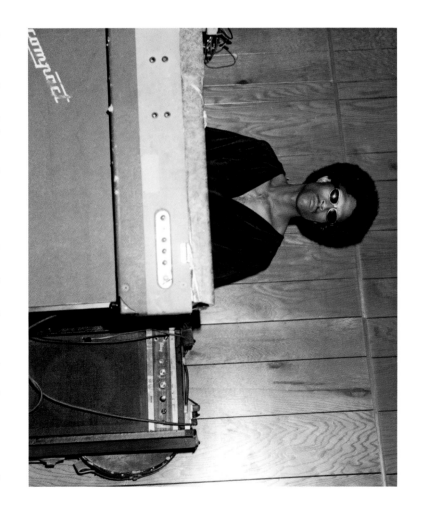

that were intended as undergarments. Sometimes the stage is welcome to a gaudy mix of all.

Johnson remembers that, as Prince, Jimmy Jam, Terry Lewis, and Morris Day and the Time hit it big, what had previously been a scene built on a hard, masculine strut of funk began to soften—a bit. The men began to wear makeup at the same time that lighter skin and Euro-model thin became prerequisites for women's success on the scene: "We were asked to lose weight, but weren't having that." Mocha also recalls Prince coming to see her band Myst play at the Riverview Supper Club and liking it. Shortly after, he put together Vanity 6, featuring three lighter-skinned, ambiguously ethnic women picturesque by 1980s model standards.

"We experience our collective crisis as African American people within the realm of the image," says bell hooks in *Black Looks*. White to black, young to old, south to north, men to women, Africa to the Americas.

However, the people in Charles Chamblis's photos do not appear to be at the point of crisis. If they are, one would have to assume that they did not know it, or had temporarily set aside the crisis to honor the moment.

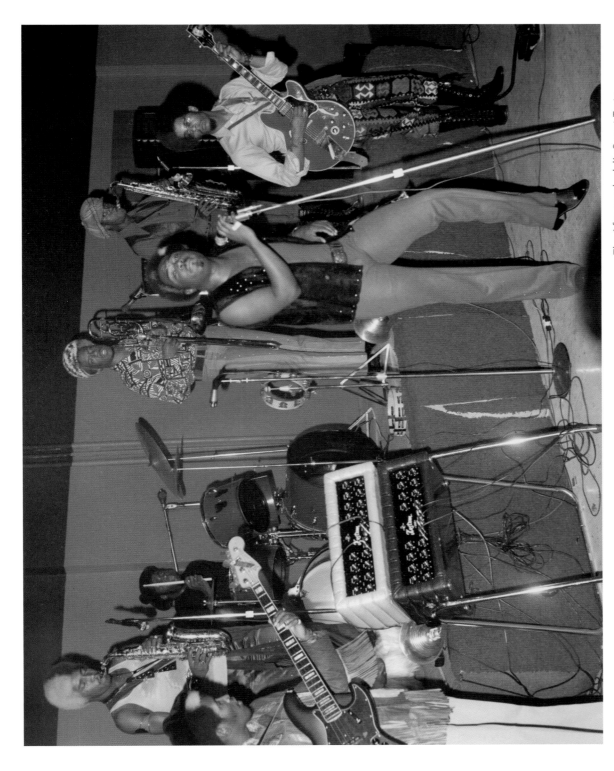

The Afro-psychedelic Sweet Taste of Sin performing at the Jet-Away Club

Prim cotillions and elegant pageants, body builders, Black Power gathering blackness at its most extravagant, the modest presentation of one's best, most professional self. The body is decorated as localized expression of the many negotiations that black people have had to make with and apart from others, as others would have to do with black people. In Chamblis's garden—for the moment—one need not ask from which direction culture flows; rather, one seeks to bring greater clarity to who is involved and what is at stake.

Pleasure. And the spirit of black beauty, integrity, and power that is bound up in the letters R-E-S-P-E-C-T. •

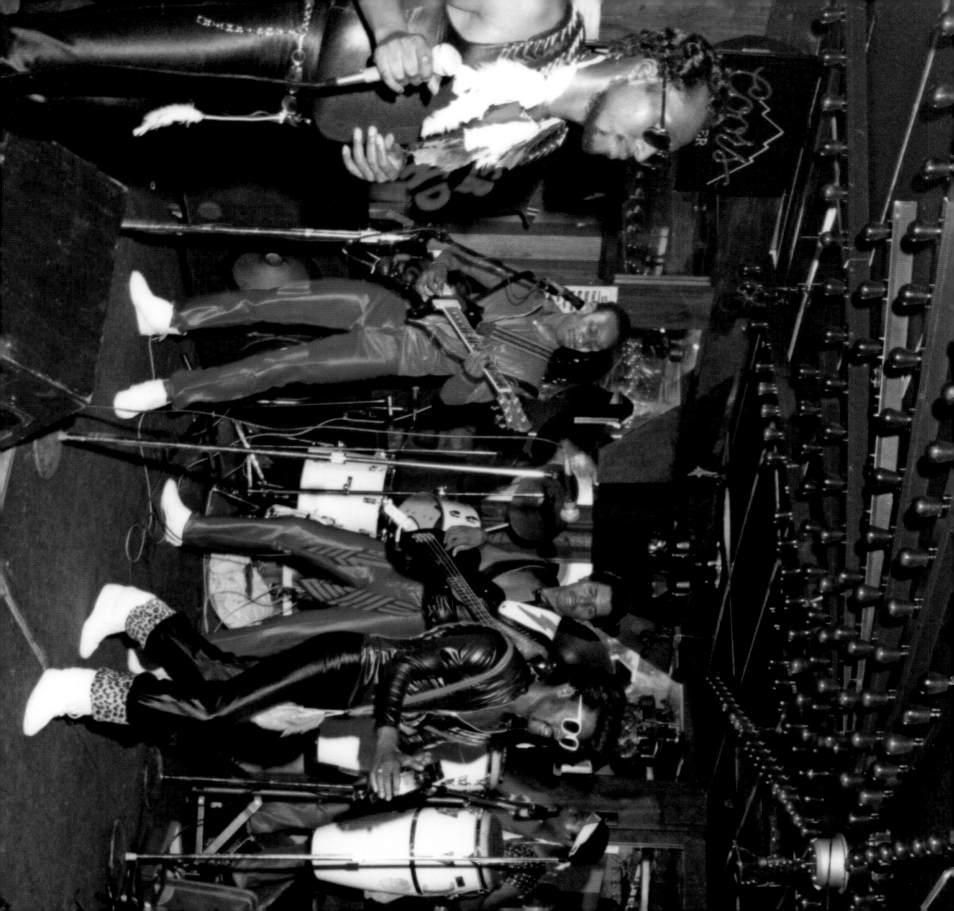

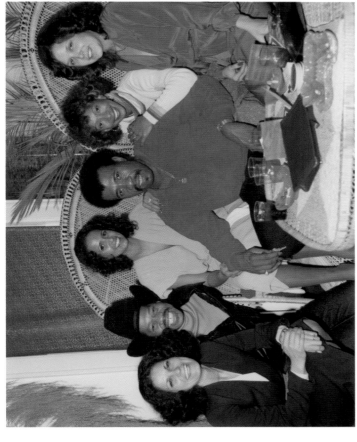

Group surrounding man in plush red sweater. Wicker chairs are to the '70s what tiki was to the '60s.

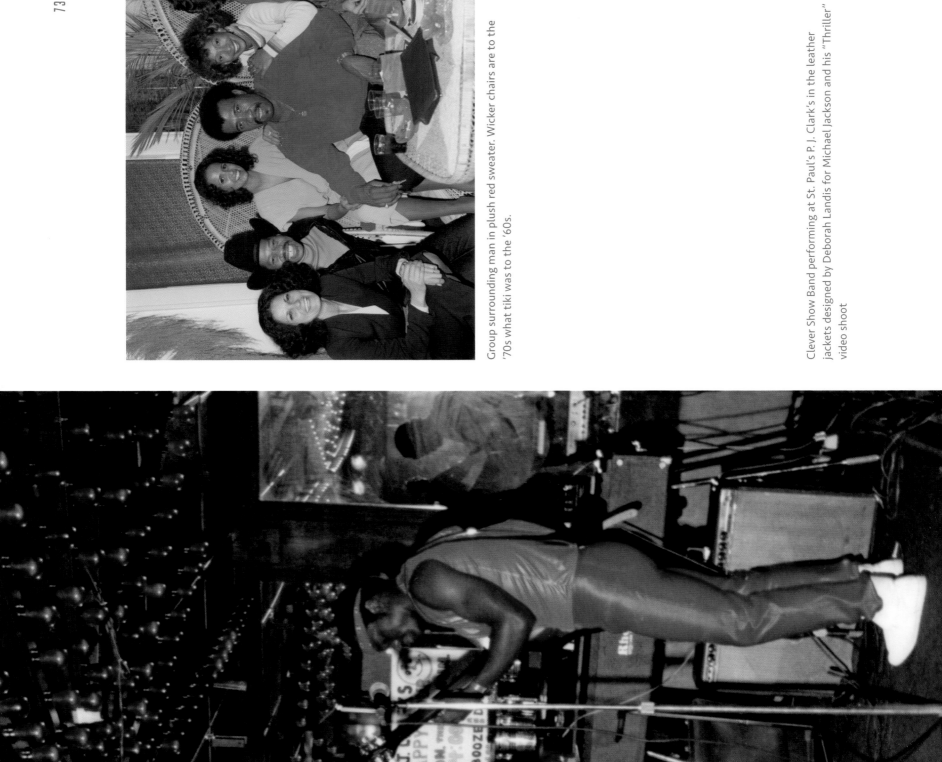

Clever Show Band performing at St. Paul's P. J. Clark's in the leather jackets designed by Deborah Landis for Michael Jackson and his "Thriller" video shoot

Angela Burkhalter in African or Asian sun hat, head wrap, and patterned dress

Fashion model dressed modestly but elegantly in gold

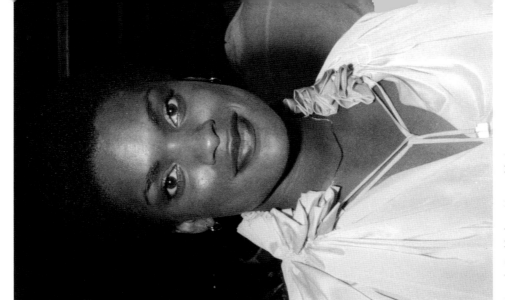

Angela Burkhalter wins Miss Black Minnesota, 1979

Angela Burkhalter. Natural hair was perhaps the most common way to express that "Black is Beautiful."

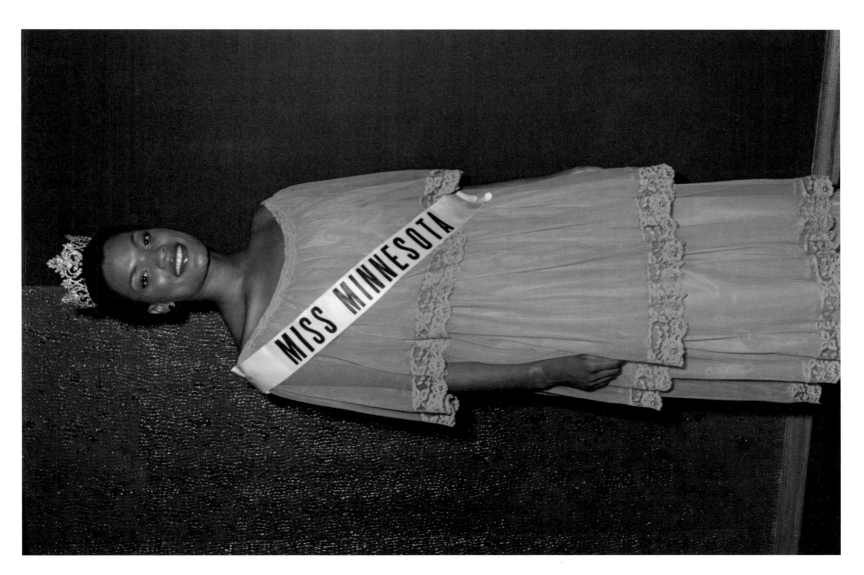

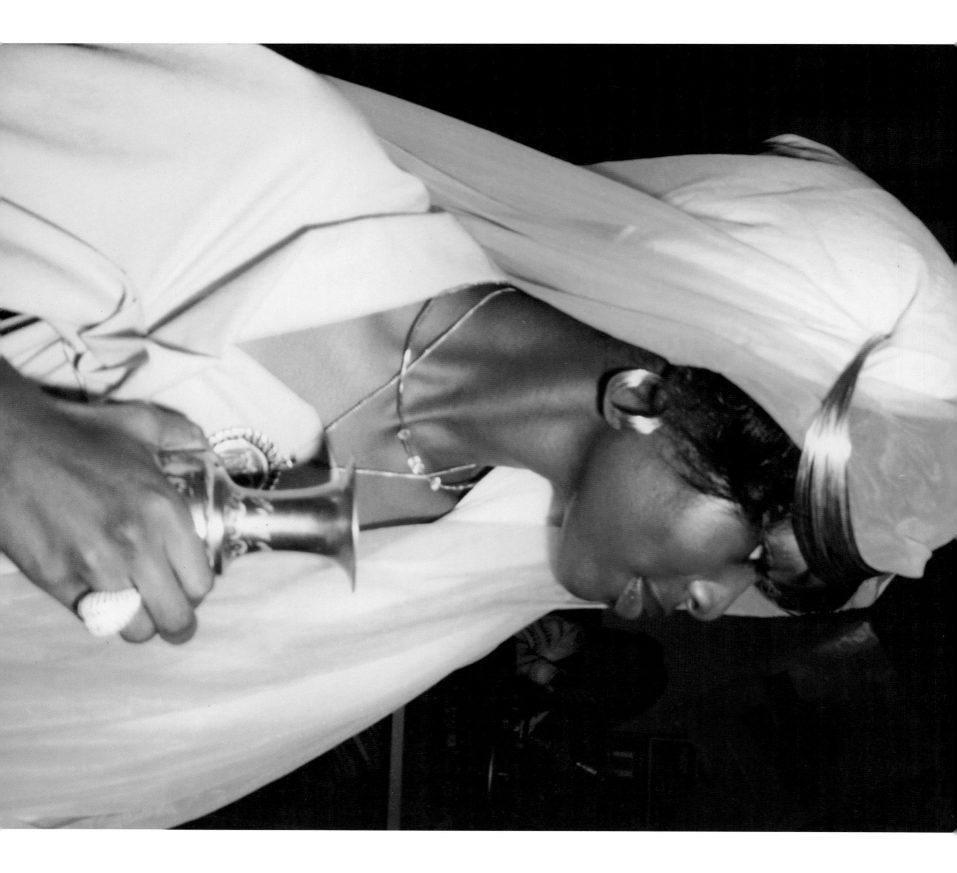

Model at a club fashion show, Minneapolis; Jimmy Jam Harris seated at left

Opposite page: Woman in headscarf with chalice. The fashion world has long traded in exotic "Orientalism." Black consciousness in the '60s and '70s also often meant global consciousness, as some began to identify as citizens of a predominantly non-white world.

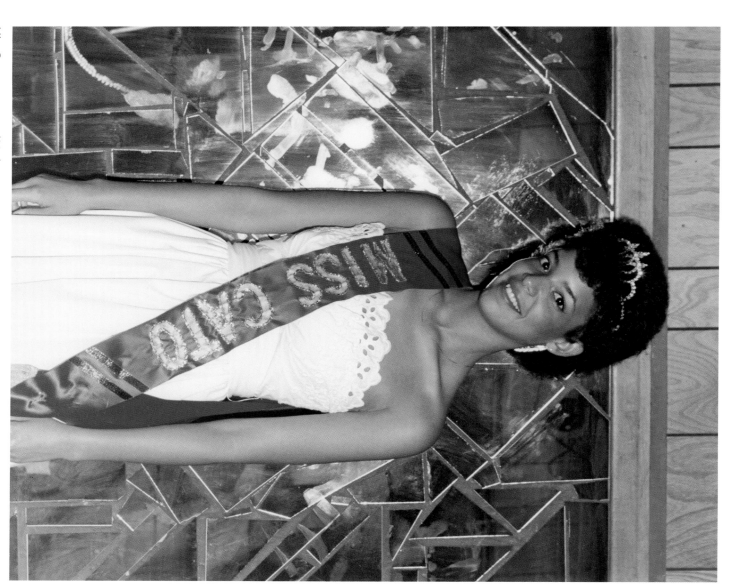

Miss Cato—or earnest '80s homecoming queen?

Runway finale at the Taste
Show Lounge

All-white business casual
on the runway

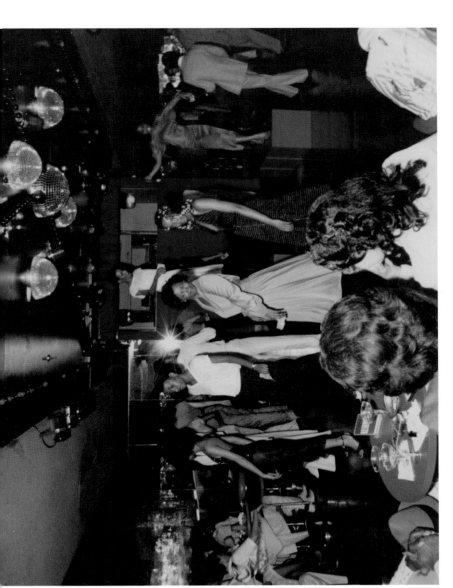

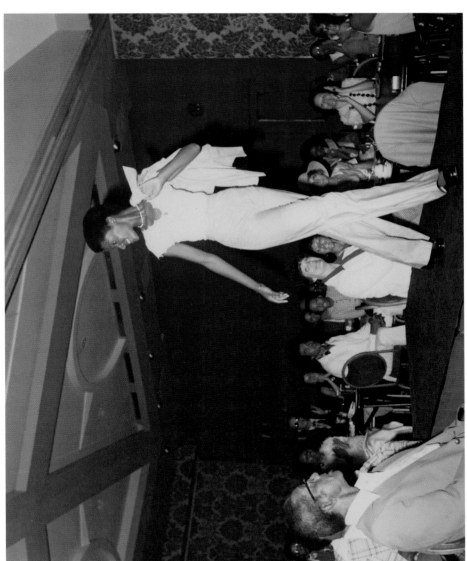

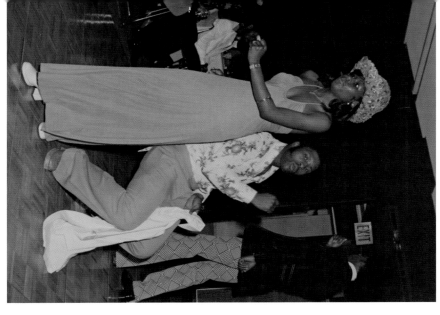

A couple matched in funky powdered pastels

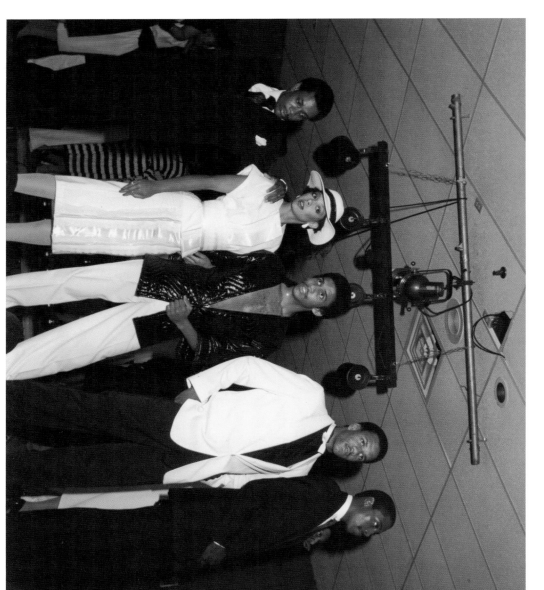

Nothing says money in the 1980s like dressing down a tuxedo

Opposite page: Kevin Jenkins photographing model Rozenia Hood Fuller sashaying in haute couture

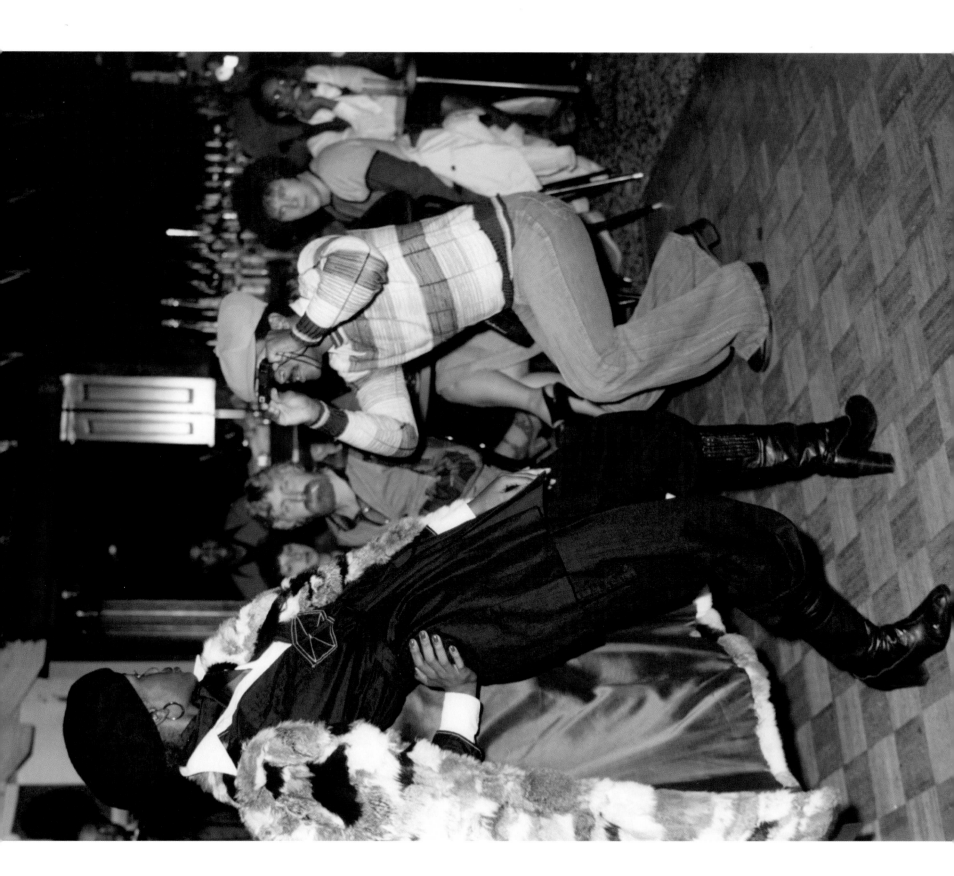

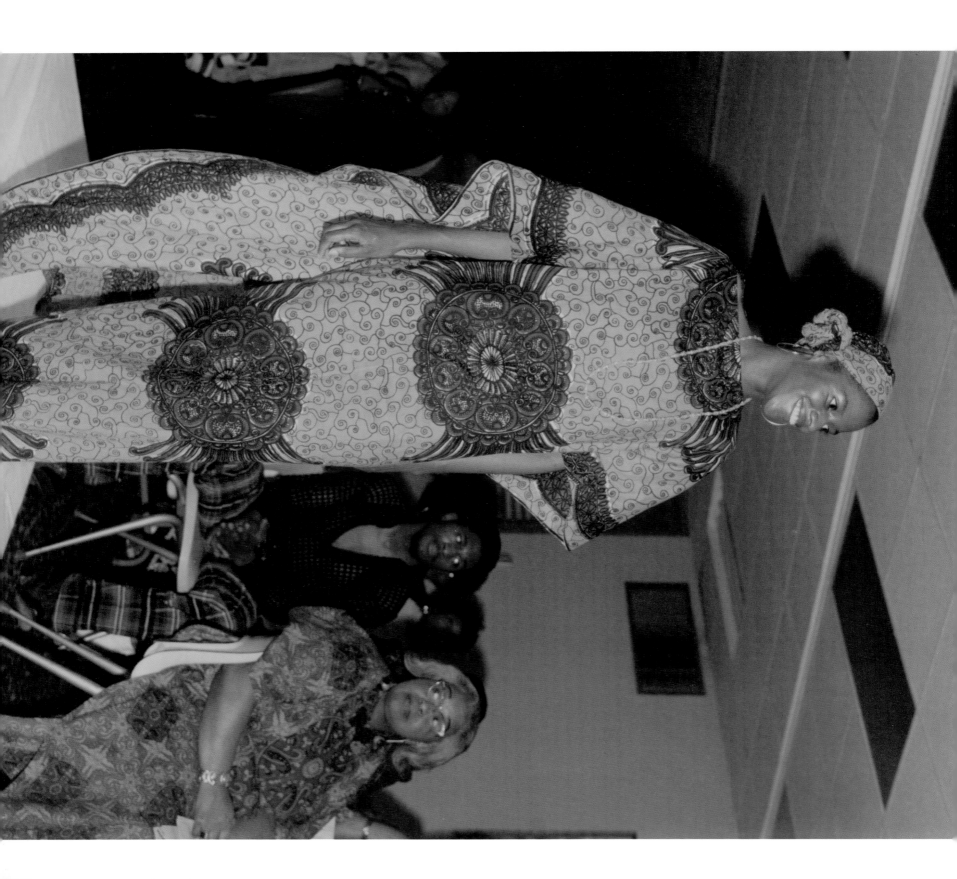

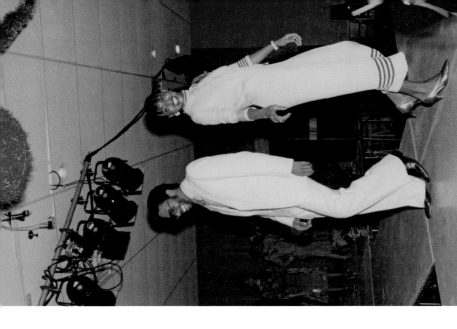

Buttoned up in all white

The soft professionalism inspired by Claire Huxtable meets the angular futurism of a Grace Jones.

Opposite page: Head wrap and African paisley

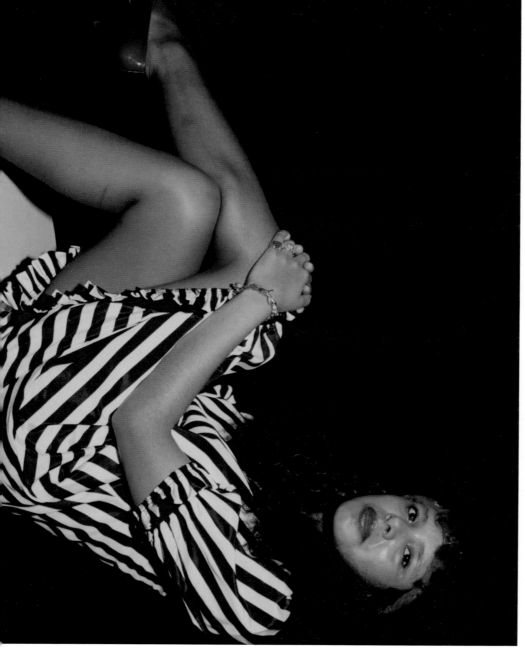

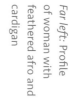

Far left: Profile of woman with feathered afro and cardigan

Left: Woman in sepia, reminiscent of '80s pop goddess Tina Turner

Woman in stripes and headband

Opposite page: Sandra Harris O'Neal as Afrocentrism and positive sexuality

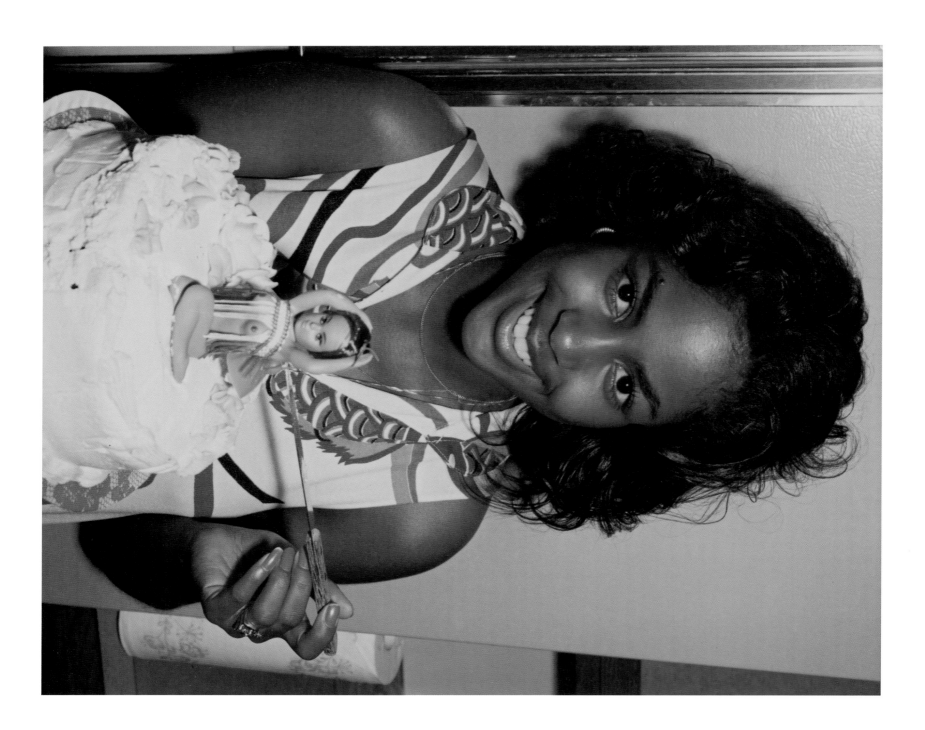

Chamblis would tell his subjects to "smile with your eyes."

Opposite page: Sweet and erotic. The back of the photo reads, "A heavy heavy picture."

Woman posing with blue painting. Chamblis's title for the photo is "White on White."

Woman with gold beads and eye shadow

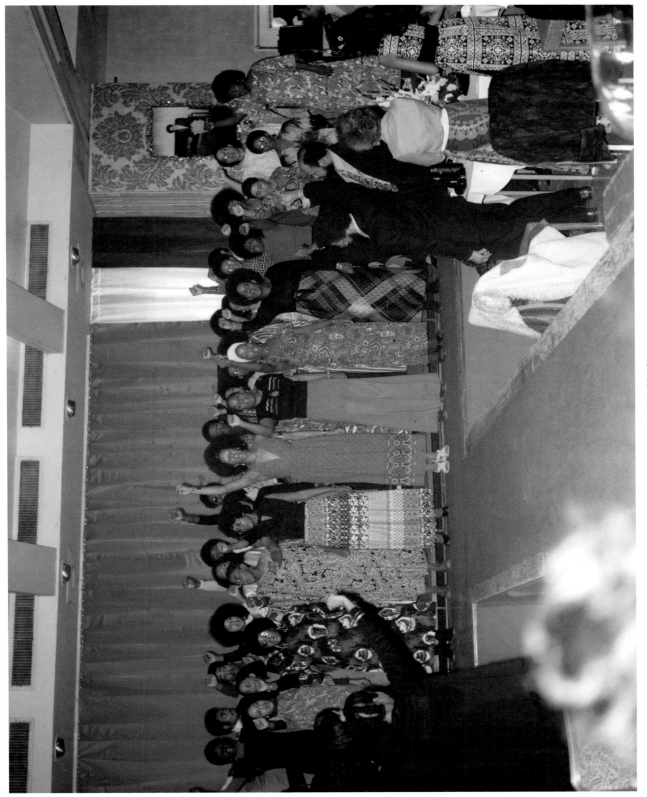

Women and audience, many of them wearing African prints, display black power.

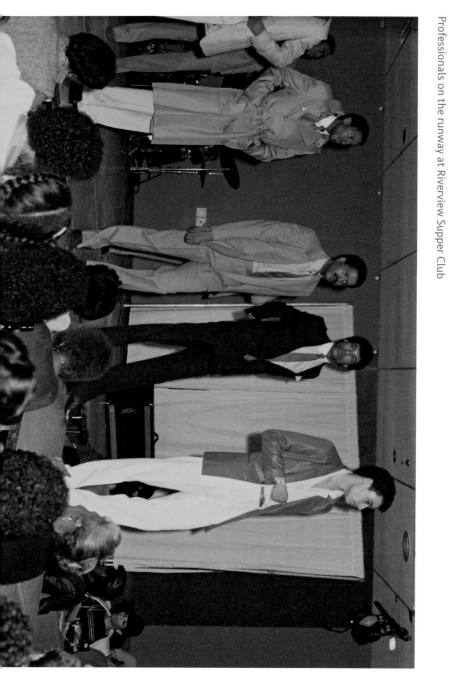

Professionals on the runway at Riverview Supper Club

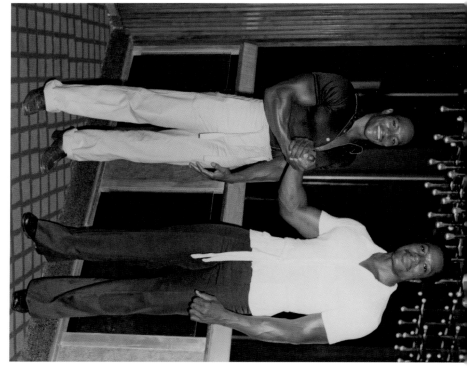

Matthew "Buddy" Bridge and Gary Hines of Sounds of Blackness

Body builder Matthew "Buddy" Bridge posing at competition

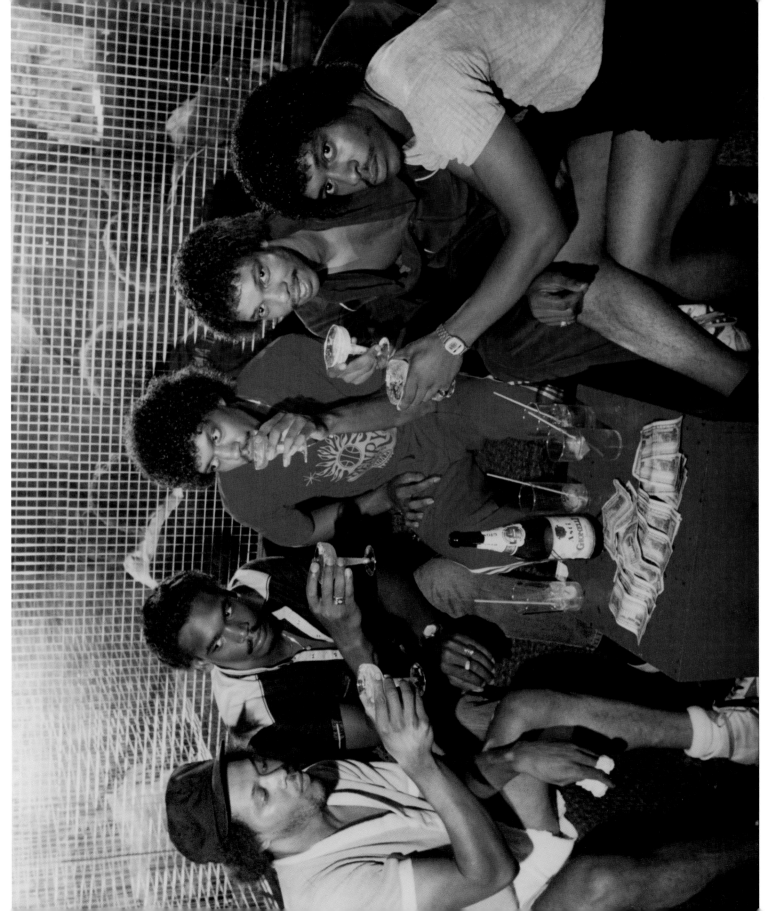

Celebrating good times with money, champagne, Jheri curls, and tracksuits at the Taste Show Lounge

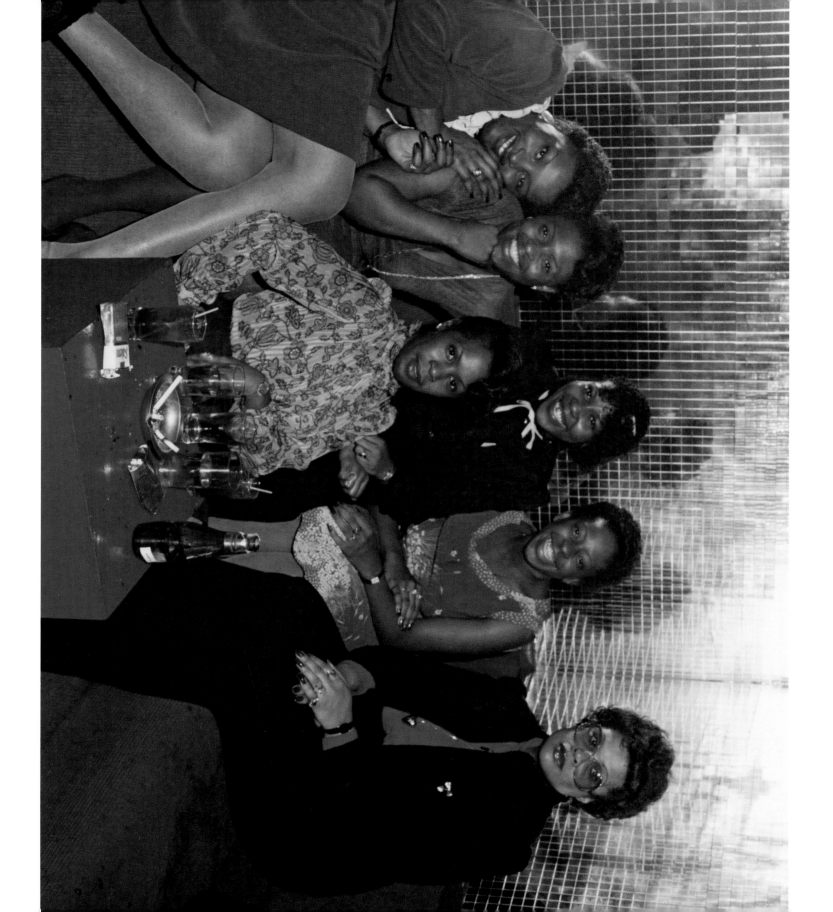

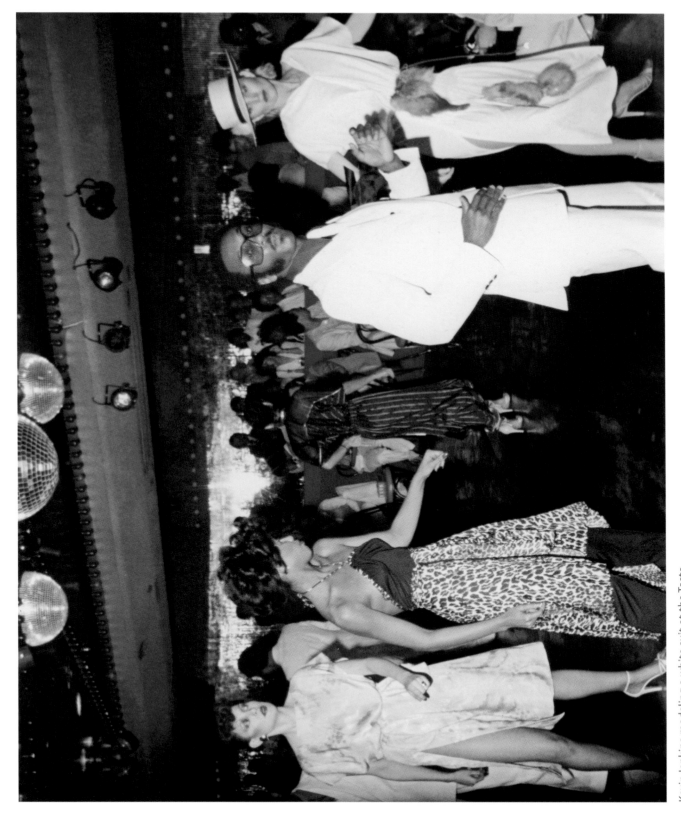

Kevin Jenkins modeling a white suit at the Taste

Opposite page: Group of women find rest from work at the Taste Show Lounge

The latest take on swing
dancing and the lindy hop
on display

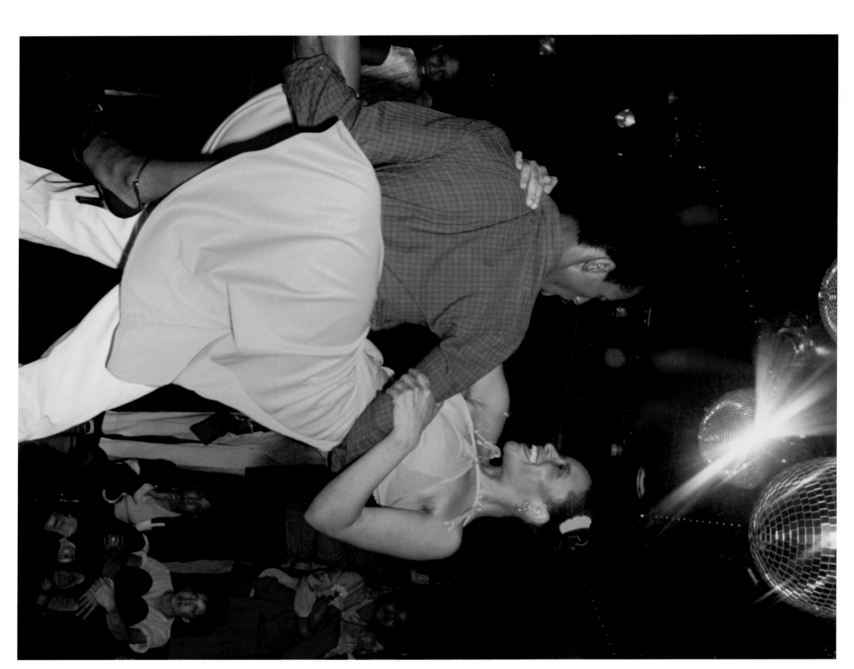

THE TWIN CITIES *Through the Lens of* CHARLES CHAMBLIS

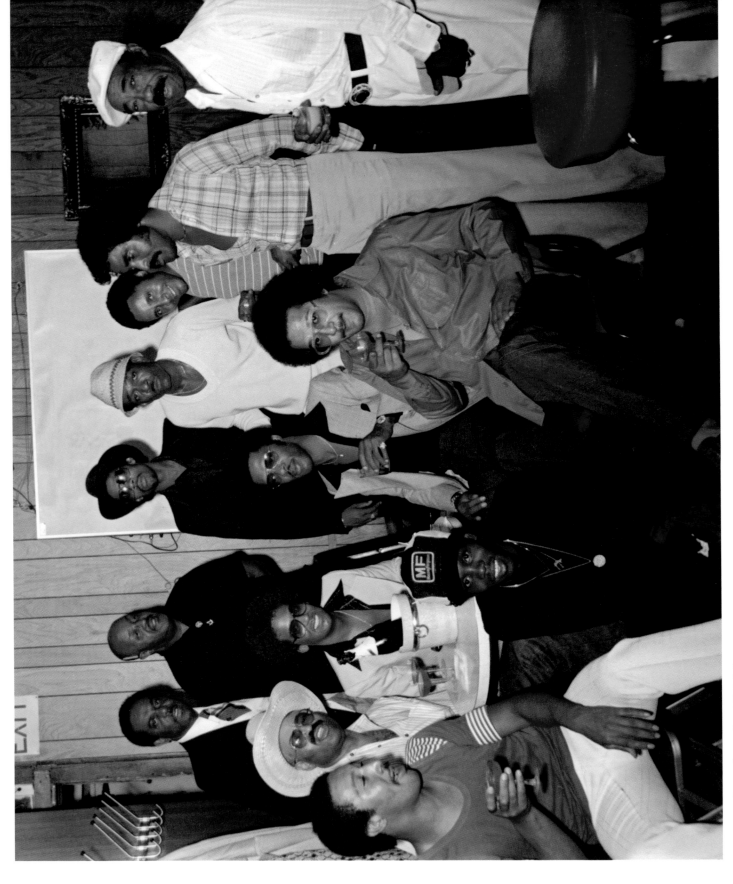

Sweet fraternity at Kato's Lounge

Decked-out club-goers encouraged to "Dance Your Ass Off" at the Taste

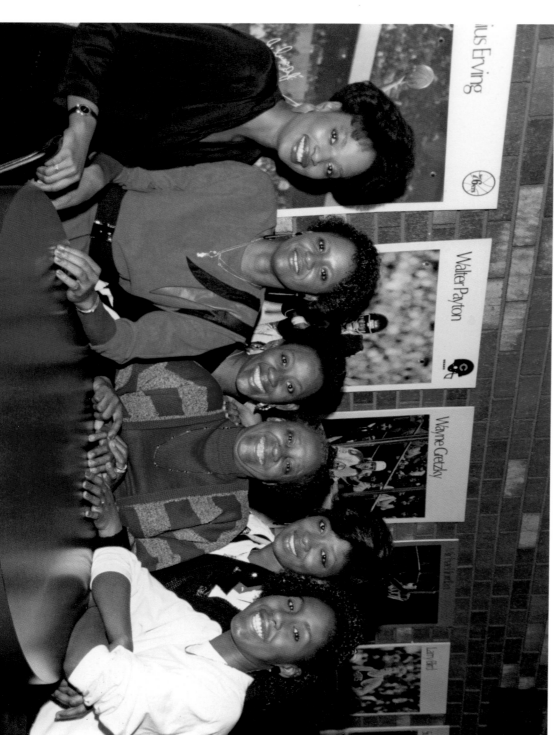

Women at Jersey's Sports Bar

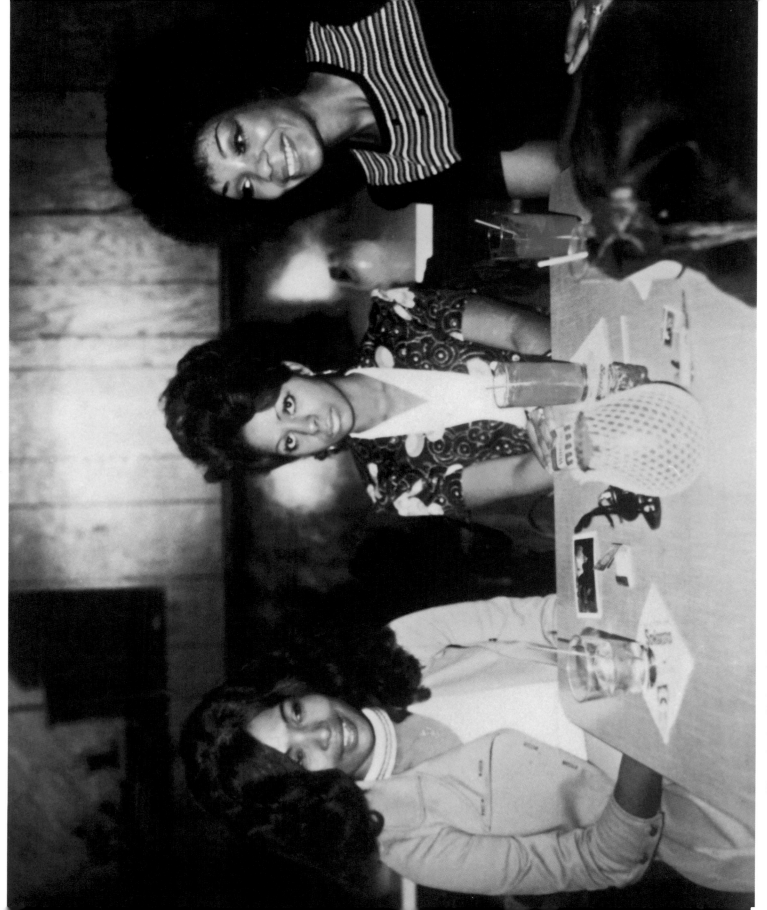

Women having drinks with their newest Polaroid

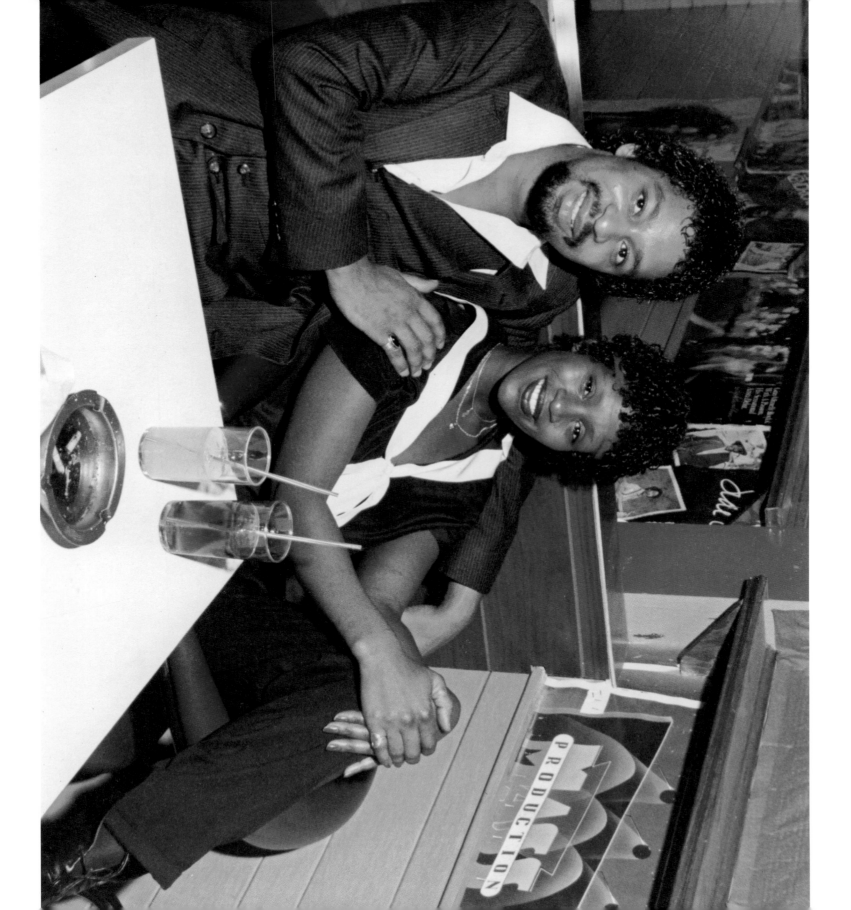

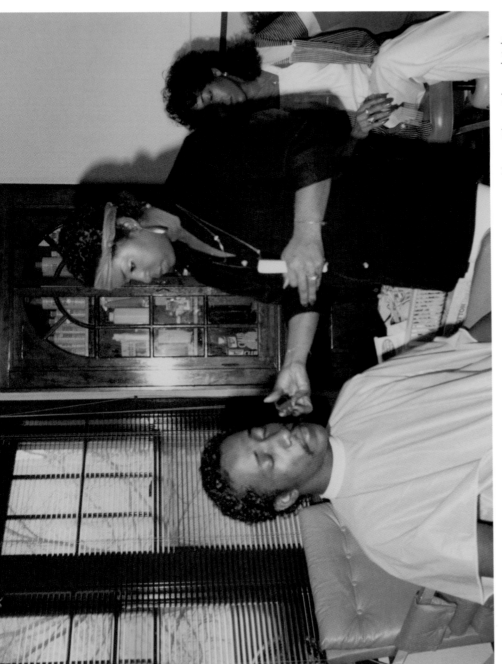

Man getting a trim and style

Women at a nightclub

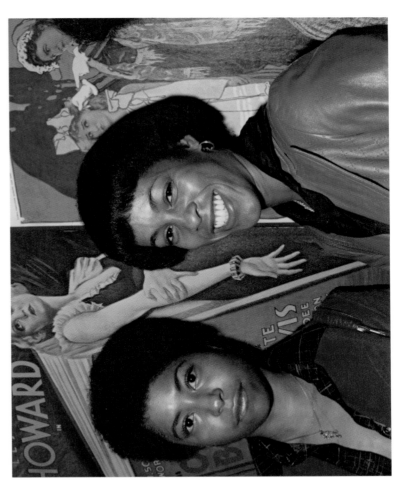

Opposite page: Ron Wilson and Wanda Nunn, their hair relaxed

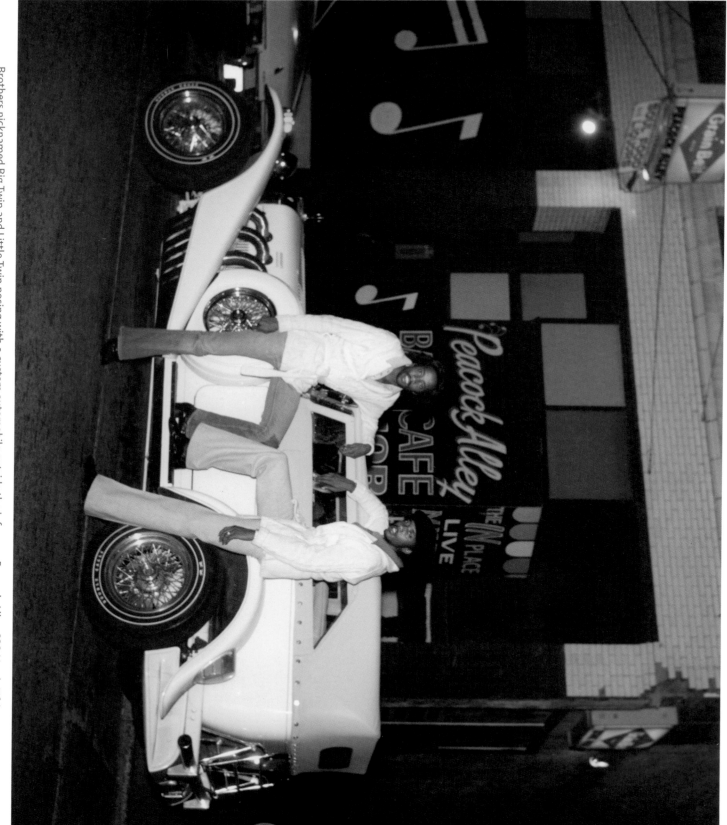

Brothers nicknamed Big Twin and Little Twin posing with a custom automobile outside the infamous Peacock Alley, 220 North Fifth Street, Minneapolis

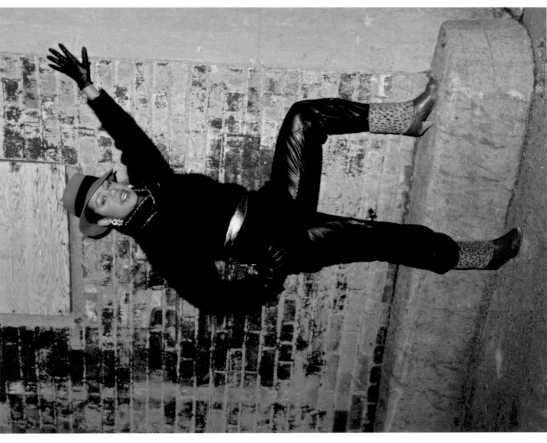

Sue Ann Carwell posing in fedora, leather, leopard-print boots, and gold belt

Sheila Rankin and friend reminding us that the Minneapolis Sound is also punk

Michael "Chico" Smith in black leather and cowboy boots

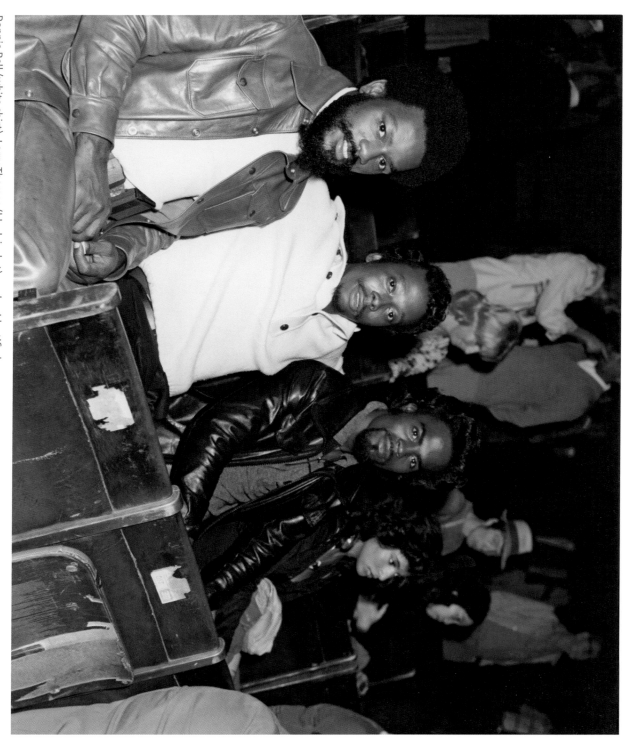

Ronnie Bell (white shirt), Larry Thomas (black jacket), and unidentified man

Opposite page: Mark Webster and two women at Lake Calhoun. Net stockings, denim halter top, and belts say "contemporary" the way only the '80s knew how.

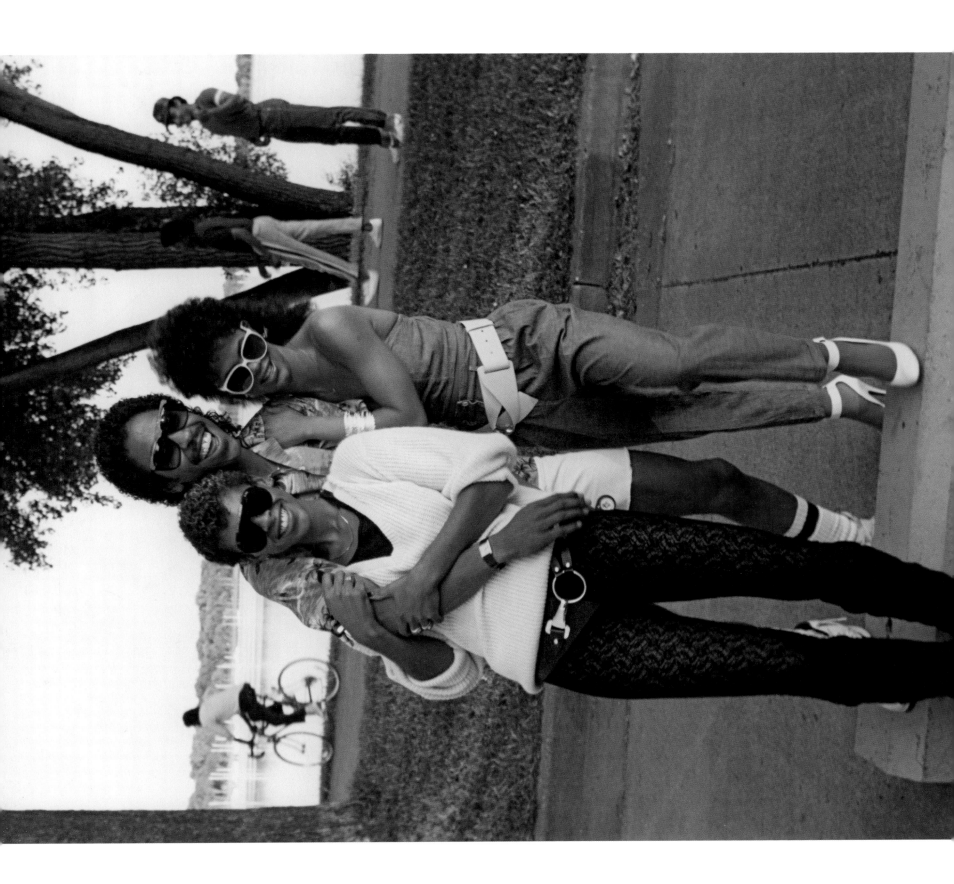

Mustachioed man in turtleneck

Opposite page: Bill Williams seated on his Cadillac

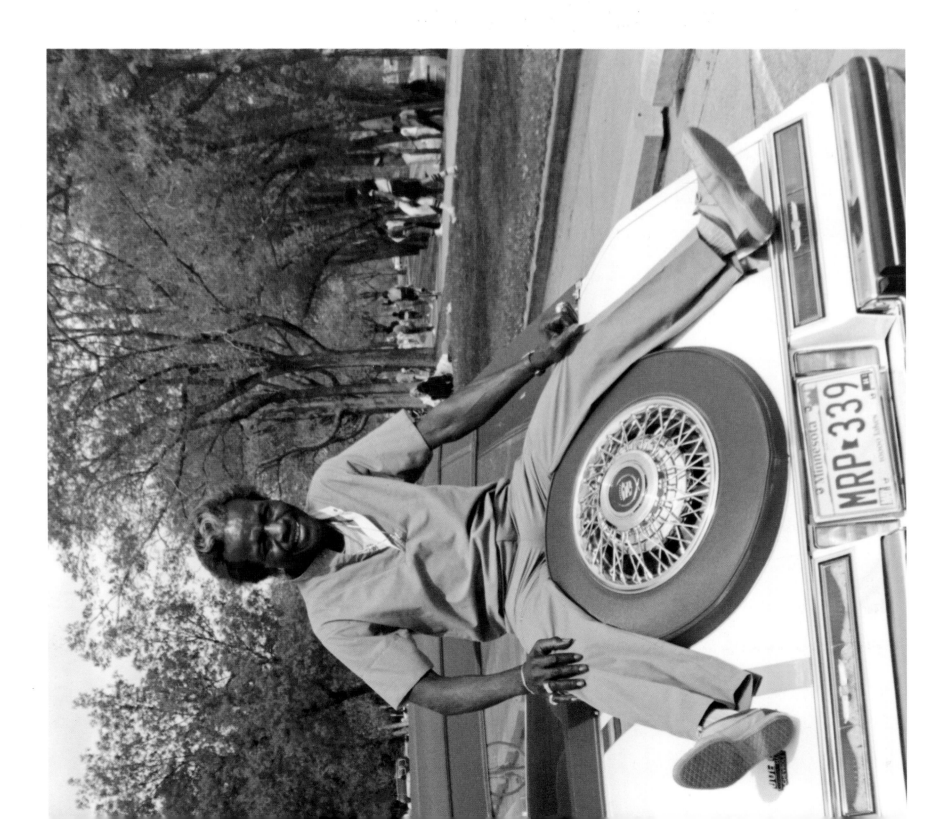

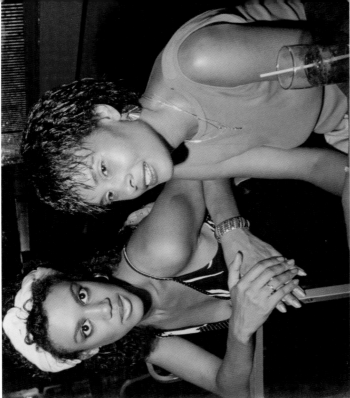

Glamour at the edge of the upper midwestern world

Left: Mi-Ling Stone and Michael Lynch

Opposite page: Masculinity at the park

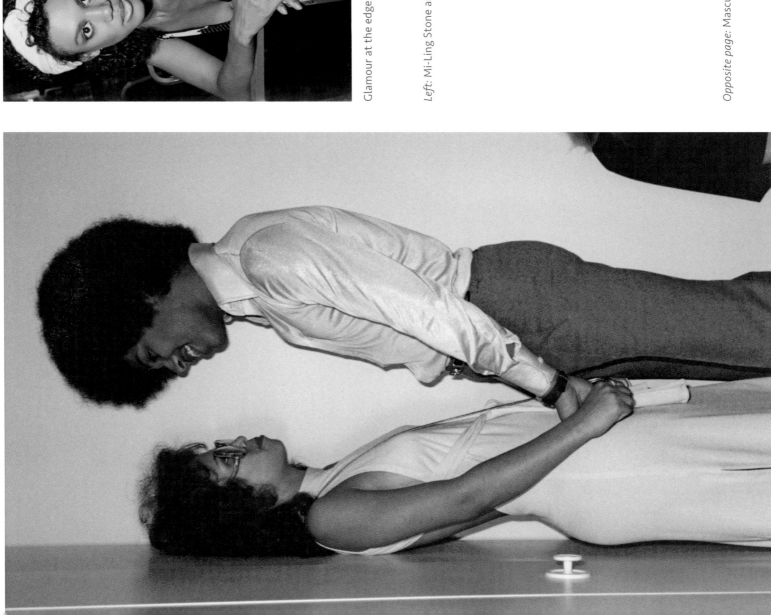

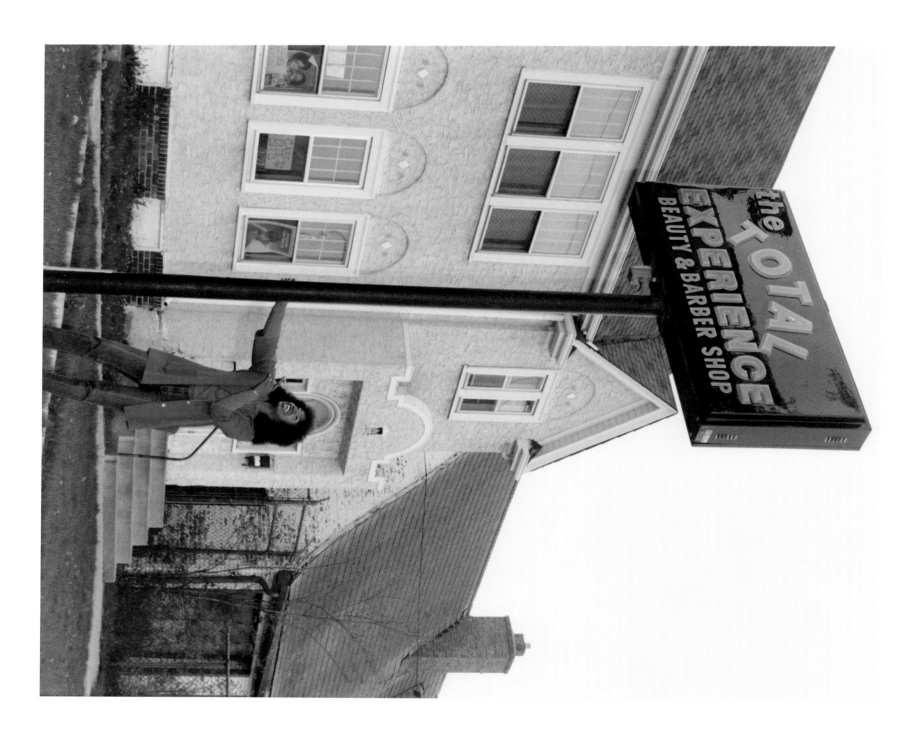

RACE MEN, RACE WOMEN

HOW WERE black communities made in the 1960s and '70s? Previously, white landowners and real estate companies formed agreements to not rent to blacks in certain areas of the city. To prevent them from renting or buying, landholders would use any number of means, including violence.

One of the ironies of restrictive housing covenants is that black people were largely left to manage their own affairs, the result being that some would have greater ownership over their own lives. St. Paul's Rondo, South Minneapolis's Central neighborhood, and North Minneapolis south of Broadway were communities where black middle and lower classes lived side by side.

This setup was normal for a time. Eventually, a number of forces contributed to black people spreading out across the city. In an interview with *Wax Poetics*, Jimmy Jam Harris described being bused to schools outside of the predominately black area of South Minneapolis where he lived. As was Prince.

There was a time when Broadway Avenue was understood to mark a do-not-enter zone for blacks living south of it. As a result, Plymouth Avenue, the closest thoroughfare to the south, became the center of black culture and commerce in North Minneapolis. Outside of churches spread throughout the neighborhood, Plymouth was where the black middle class was most visible. Carl Eller Liquors, the old and new Way, John Warder's First National Bank, Total Experience salon, Estes Funeral Home, Odell's Records, Northgate Roller Arena, King Supermarket, and other businesses served, for a time, blacks who lived in the area.

When the cumulative effects of discrimination came to a head in July 1967—as it did in black communities across the country during the later years of the decade—resulting in fires and looting along Plymouth Avenue, it sparked the gradual exodus of the mobile members of the community, further isolating the north side.

Opposite page: Total Experience Beauty & Barber Shop

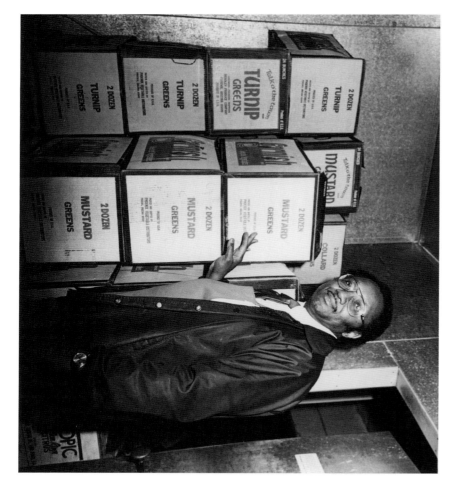

Leroy King and his tower of greens at King Supermarket

"Thinking about moving back?" By the late 1970s, developers of suburban-standard "gated" housing communities like Willard-Hay, Homewood, and Lyn-Park ("the suburb in the city") advertised in black papers like *Insight News* in an attempt to beckon the black middle-class families who had fled.

Two worlds, one bearing more of the responsibility for the other. "Mr. King [of King Supermarket] helped a lot of people," recalled former store manager Shirley Sanders. "The great thing about it, few people knew it and he didn't want any credit for it. I knew from seeing firsthand. When some customers had no social services, Mr. King was their social service provider."

Leroy King sold the family business in 1992, following seventeen years of service. "The neighborhood changed," he said.

In the following selection of photographs, Chamblis captures the mainstream of black life in the Twin Cities. People of service, enterprise, leisure, sport, and pride; people devoted to family and community. Visible proof of a simple truth which some might distort and deny: that we too are just people. ●

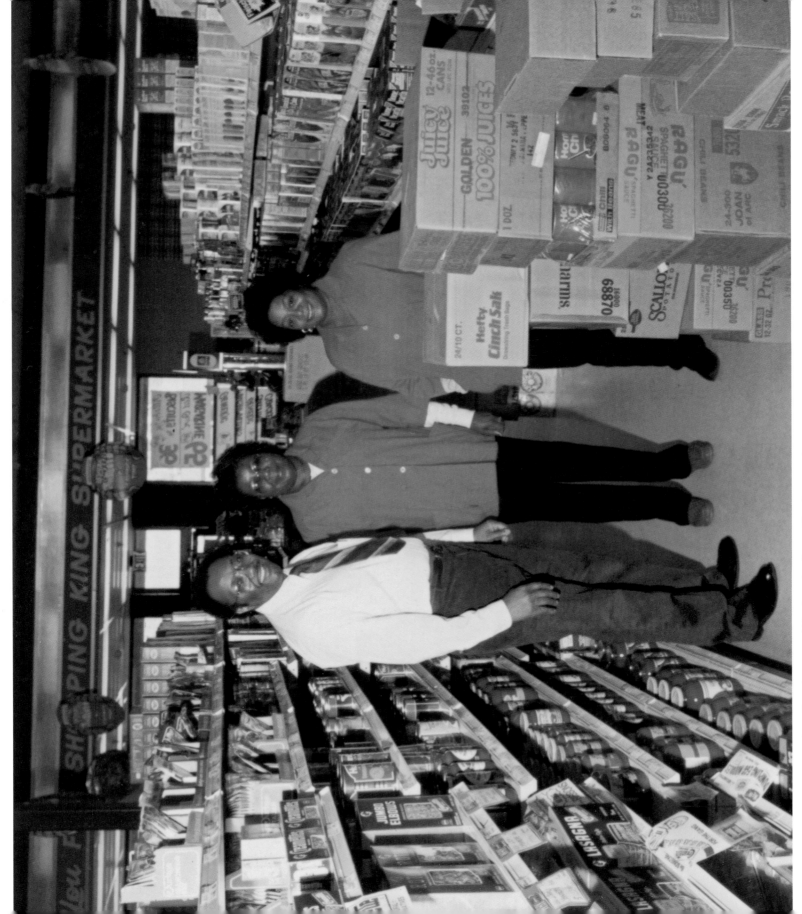

Leroy King, his wife, Minerva, and his sister, Louise, at King Supermarket

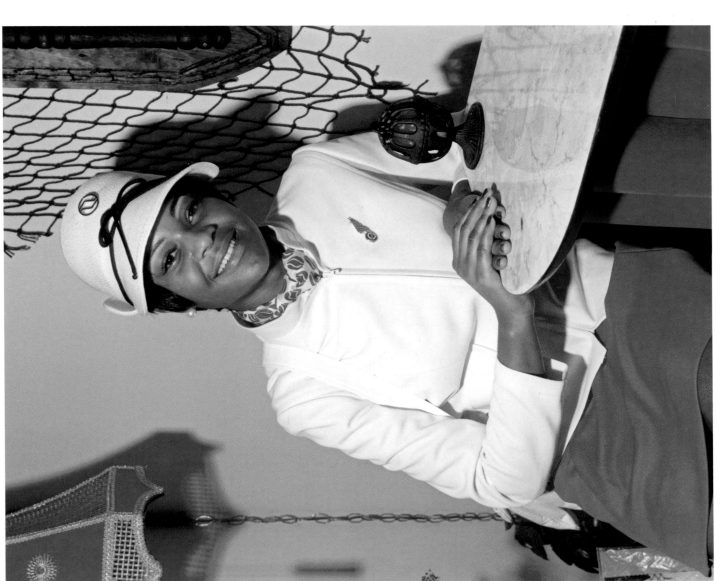

Joyce Lewis, a Northwest Airlines stewardess and, according to Walter Scott's pictorial *Minnesota's Black Community*, "winner, four beauty contests."

Opposite page: Metro Transit bus driver

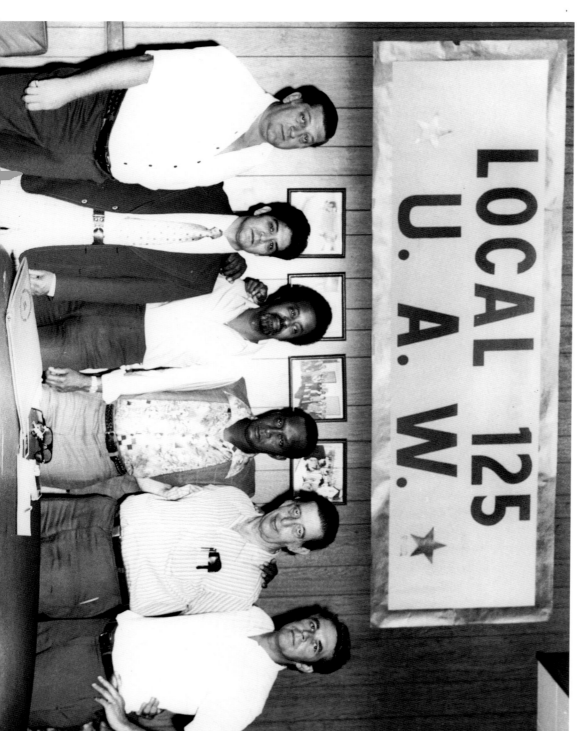

Auto Workers Local 125

Physician checking patient's heart

Pat Dobbins, Norma Jean Williams, Launa Q. Newman, publisher of *Minnesota Spokesman-Recorder*, and Jean Fjerstad

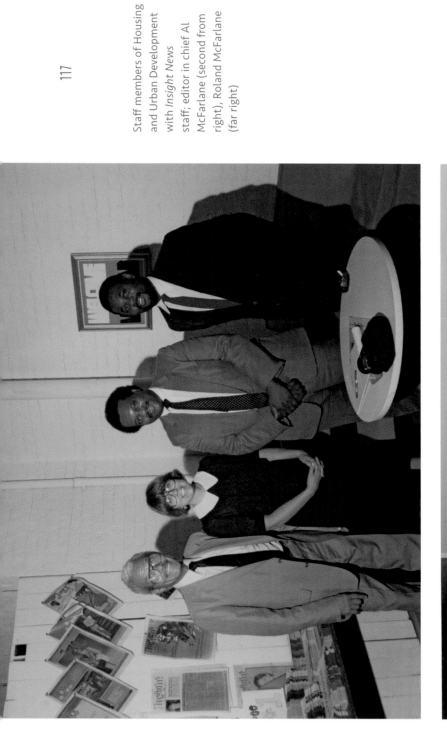

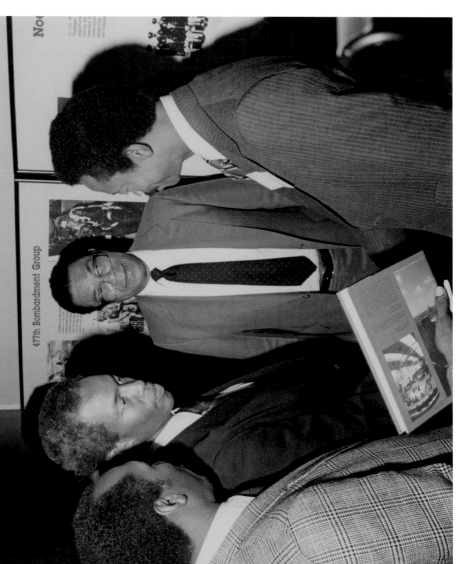

Staff members of Housing and Urban Development with *Insight News* staff; editor in chief Al McFarlane (second from right), Roland McFarlane (far right)

Opening of an exhibit documenting African American participation in the military's air forces

Opposite page: Wallace "Jack" Jackman, copublisher of *Minnesota Spokesman-Recorder*

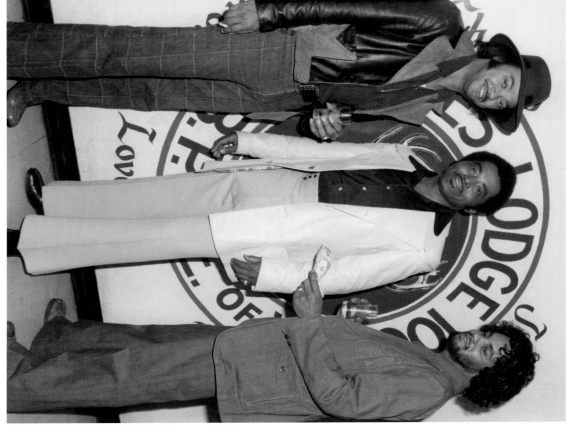

Right: Champagne celebrations

Below: Men at Elks Ames Lodge

Roosevelt Gaines, a close friend of Charles Chamblis and former program manager at Minneapolis Urban League

THE TWIN CITIES *Through the Lens of* CHARLES CHAMBLIS

Members of the Prince Hall
Grand Lodge

Event in honor of Anthony Brutus Cassius at Riverview Supper Club

Red Presley, Fred Williams, Ron Edwards, Walter Fauntroy, and others at an Urban League event

Opposite page: Twin Cities civil rights activist W. Harry Davis greeting others at a conference

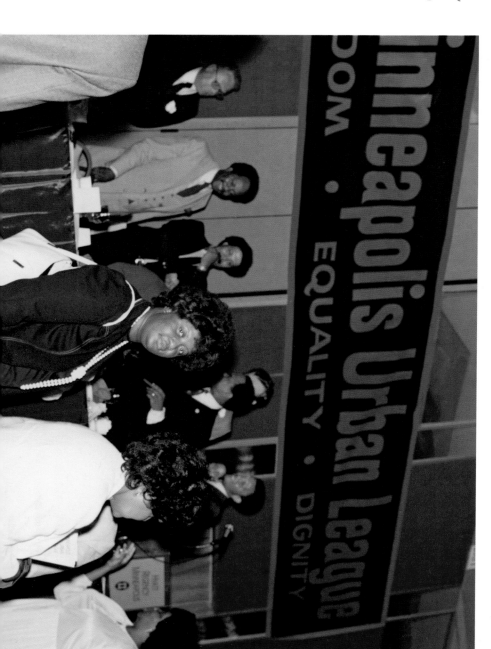

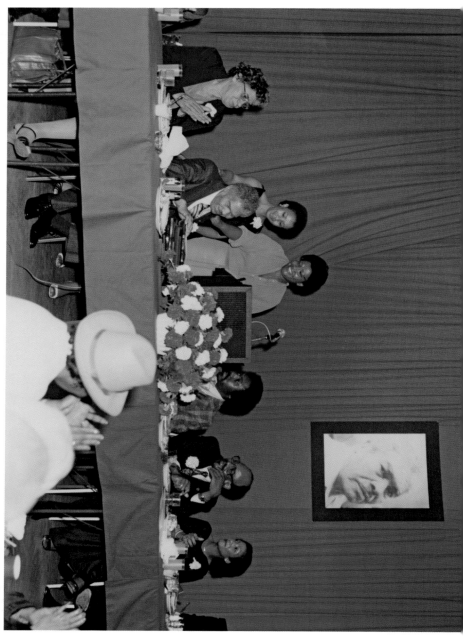

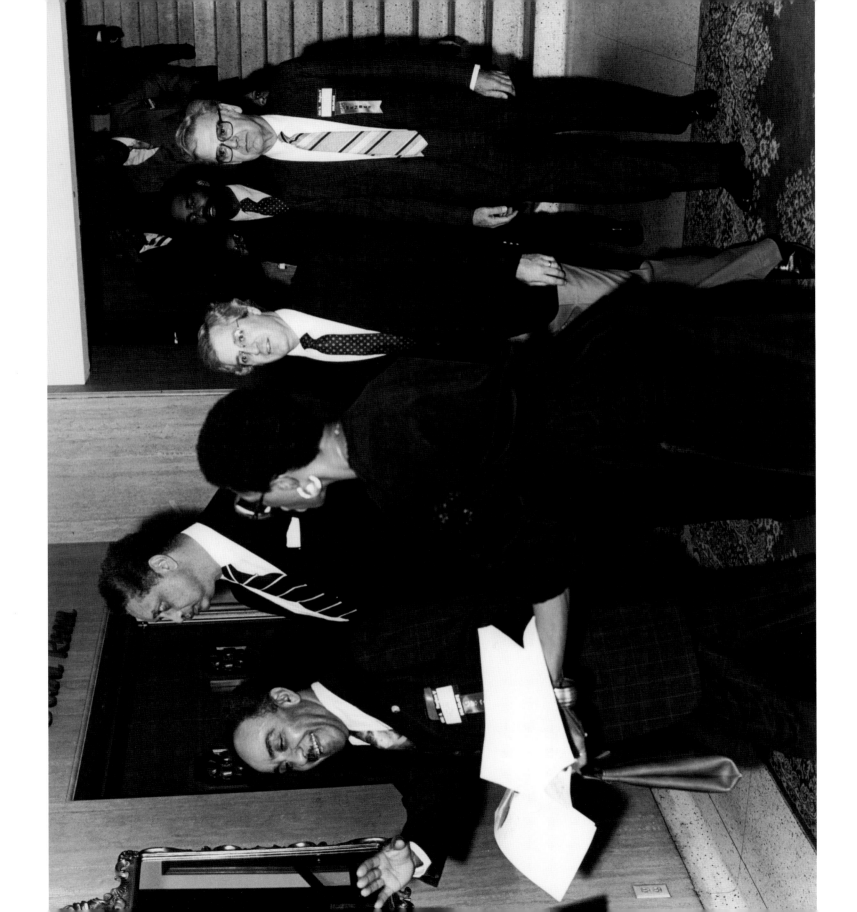

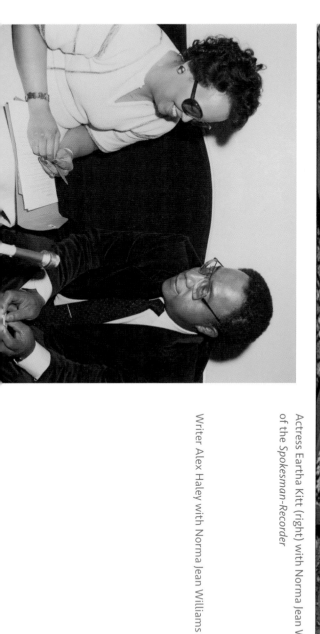

Writer Alex Haley with Norma Jean Williams

Actress Eartha Kitt (right) with Norma Jean Williams
of the *Spokesman-Recorder*

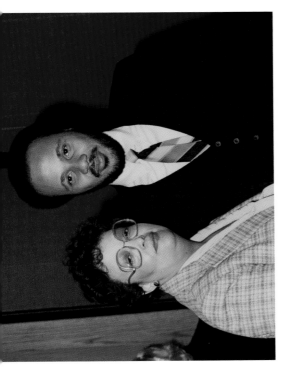

Martin Luther King III with Norma Jean Williams

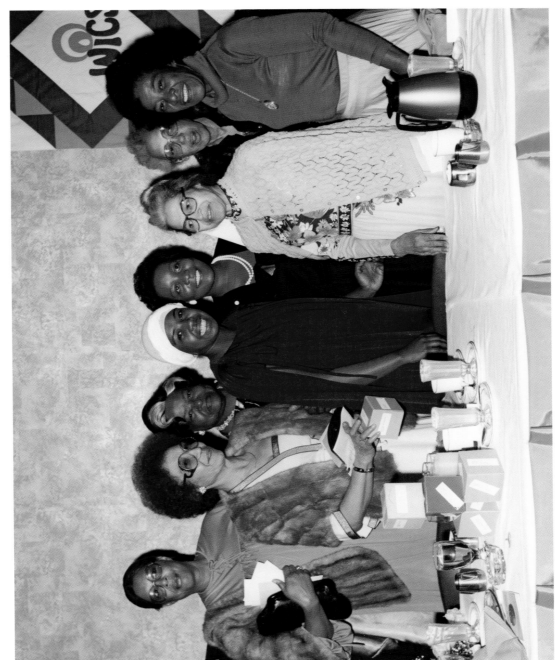

Event honoring civil rights icon Rosa Parks. Allie Mae Hampton (third from left), Gloria James (middle in brown), Rosa Parks (third from right), Jackie Mayberry (second from right)

Minnesota Viking Alan
Page (second from right)
at the Taste Show Lounge.
Page was elected to the
Minnesota Supreme Court
in 1992 and served until
2015.

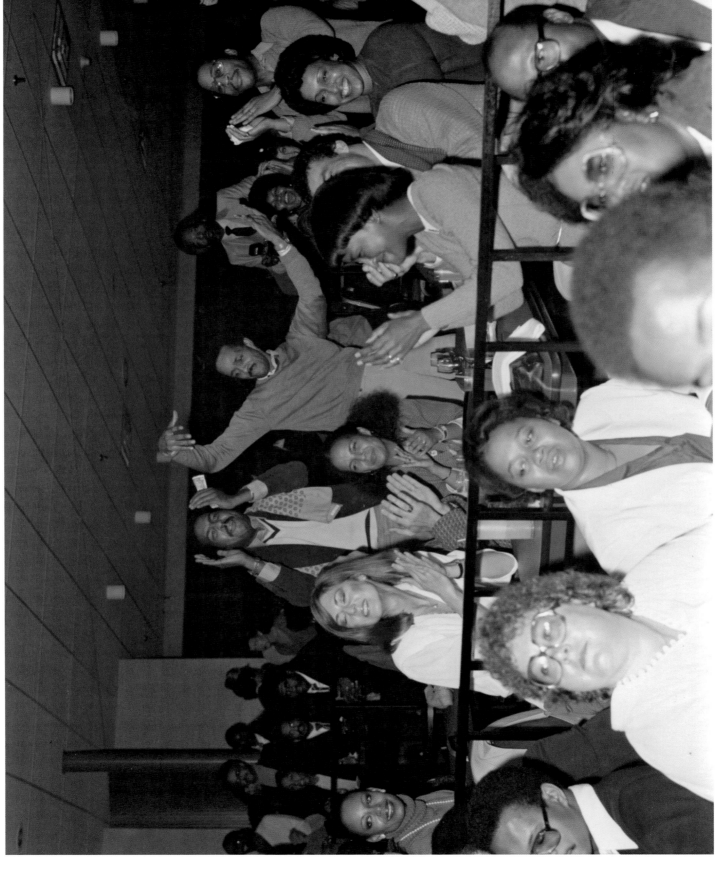

Archie Givens Jr., son of the first black millionaire in Minneapolis, Archie Givens Sr., standing and clapping (left) amid a crowd at the Riverview

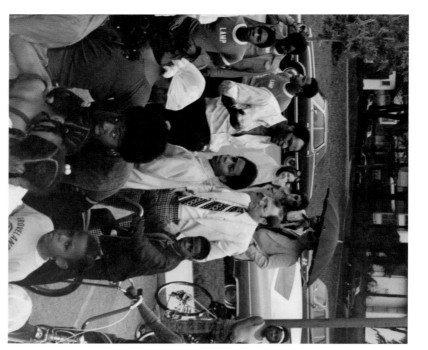

Carl Eller talking to a group. Eller, a retired Minnesota Viking and former owner of Carl Eller Liquor Stores, now works as an addiction counselor.

Jerry Ray and Johnny Ray on their motorcycles at Lake Calhoun

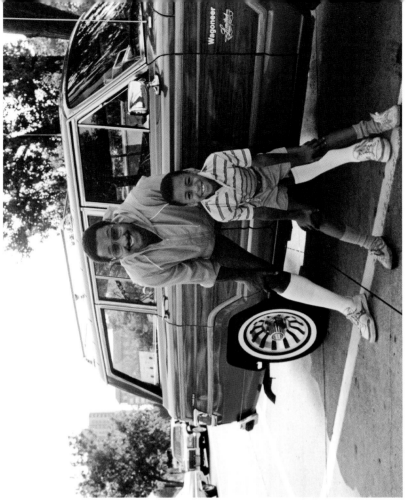

Minnesota Viking Chuck Foreman and his son, Jay Foreman, at Lake Calhoun

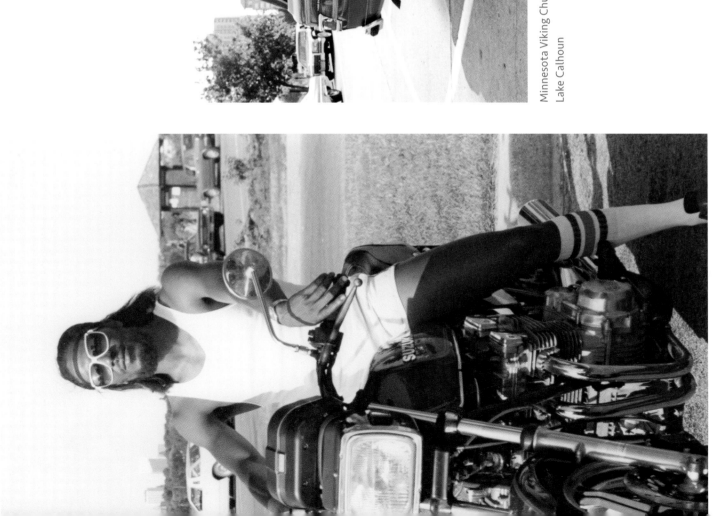

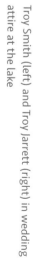

Man posing with his Cadillac

Opposite page: Wedding group

Troy Smith (left) and Troy Jarrett (right) in wedding attire at the lake

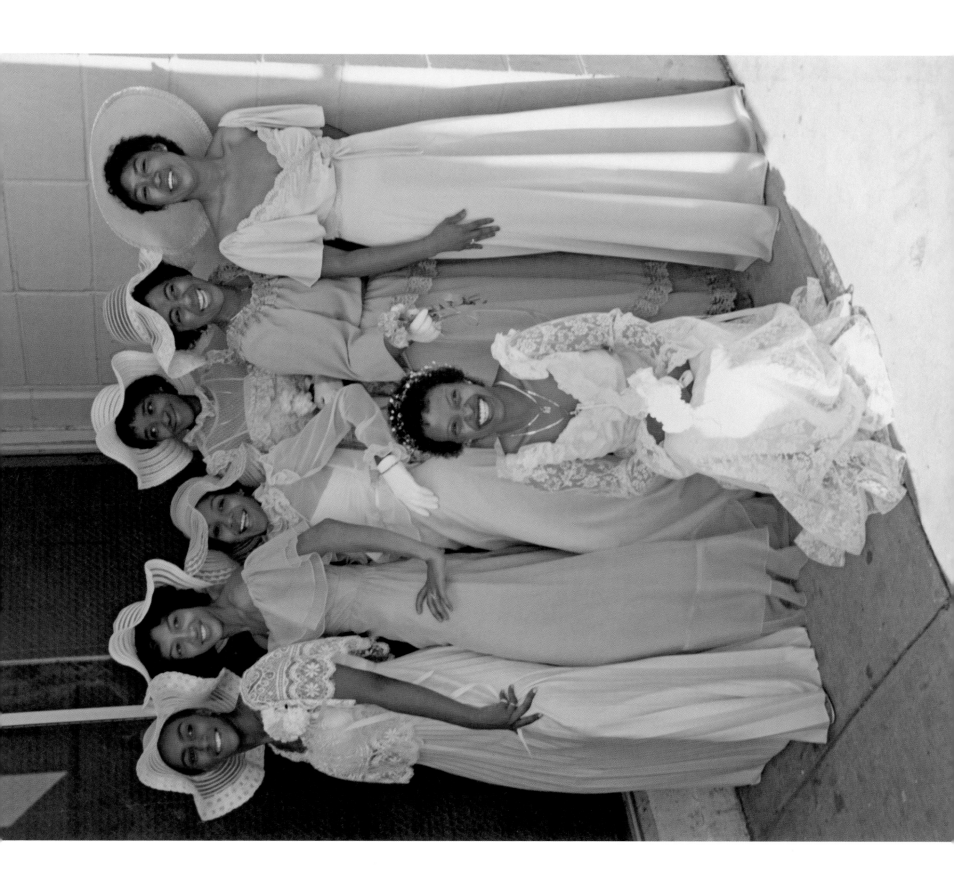

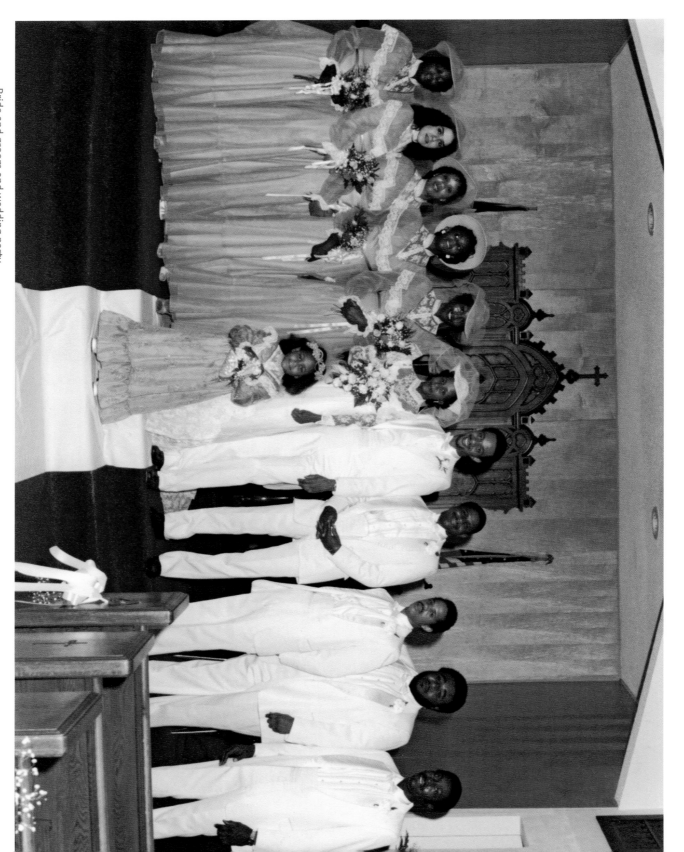

Bride and groom and wedding party

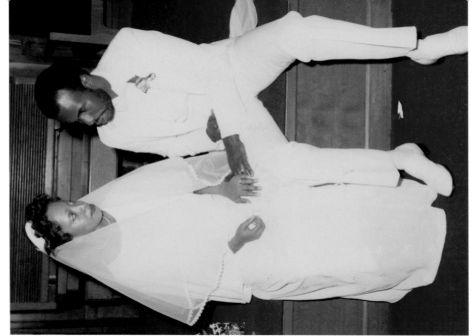

Alvin Irby and bride

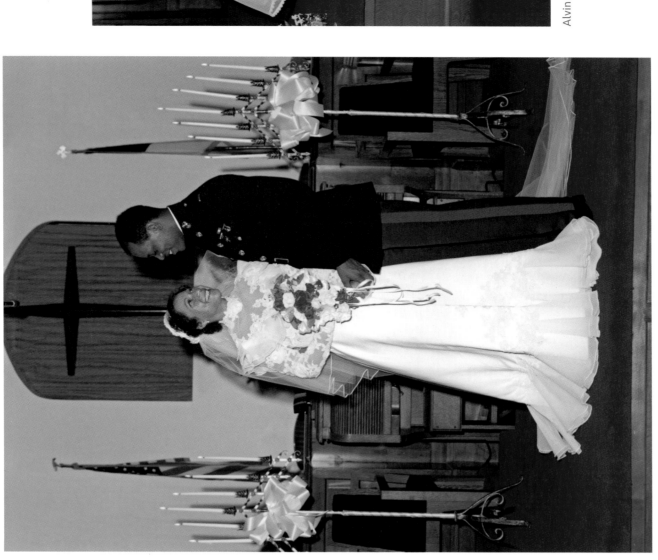

Wedding of Bruce Giron and Paulette Herndon at Pilgrim Baptist Church

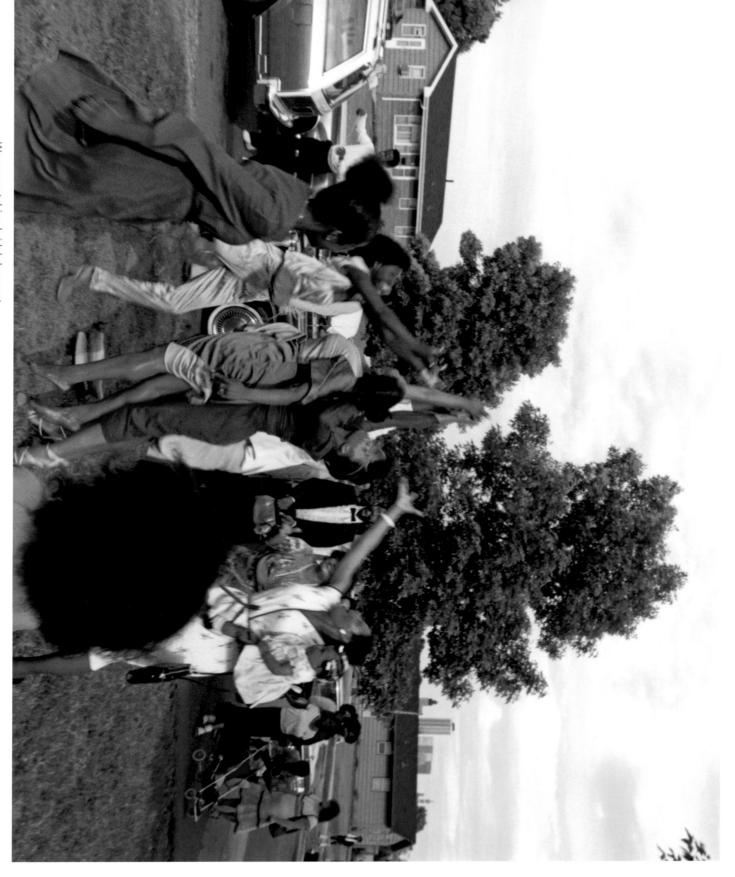

Women catching bride's bouquet

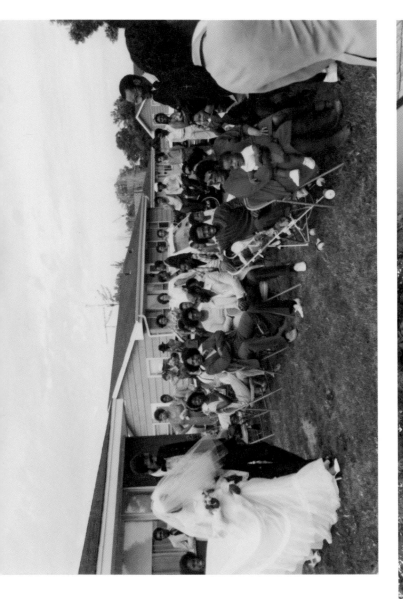

Right: Wedding in front yard of a residence

Below: Scofield family reunion, Theodore Wirth Park

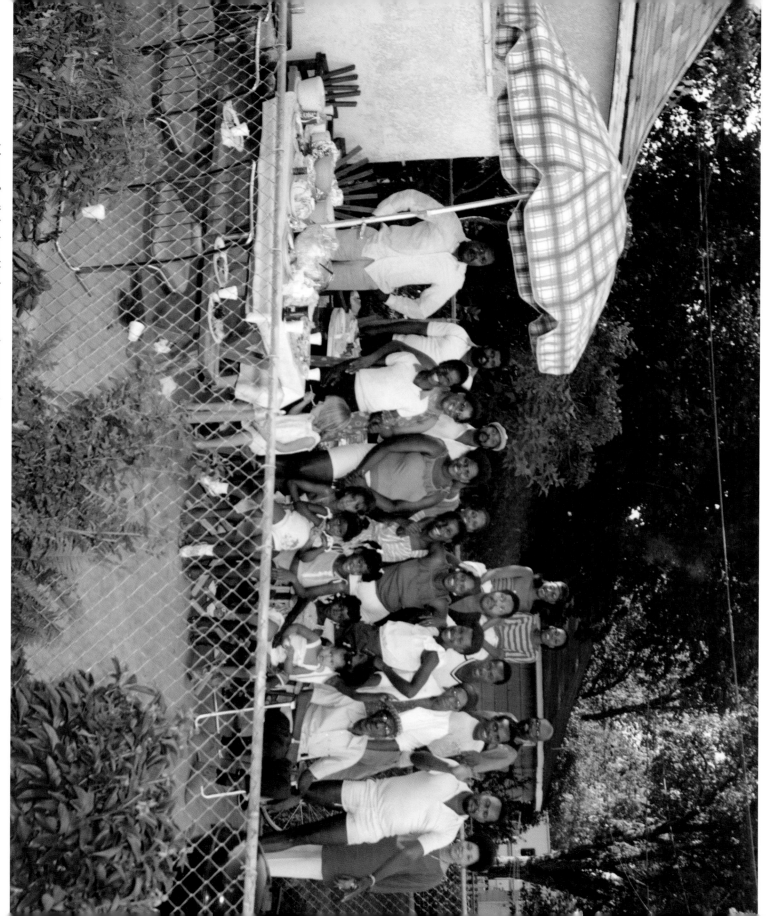

Johnson family backyard barbecue, North Minneapolis

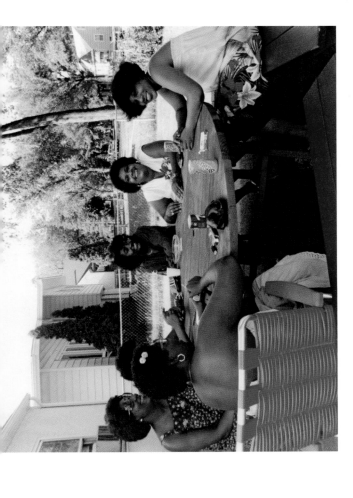

Women seated around a backyard picnic table

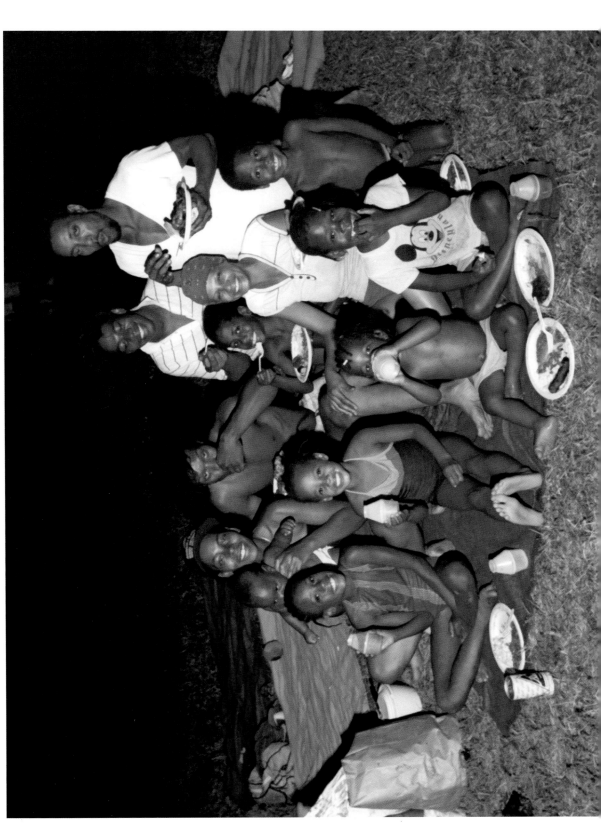

Picnic at night

Brian Richardson in
sunglasses at Lake Calhoun

Sister and brother

Softball player

Opposite page, top: Cozy Bar softball team

Opposite page, bottom: The Way women's fast-pitch softball team

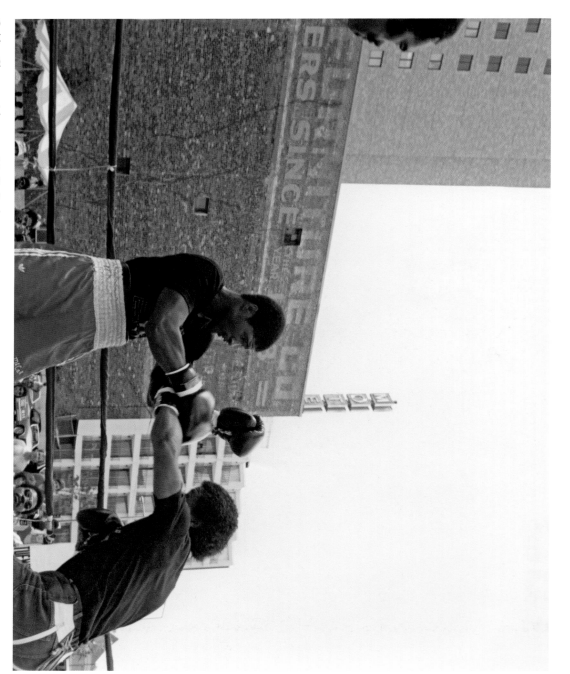

Golden Gloves outdoor event in St. Paul

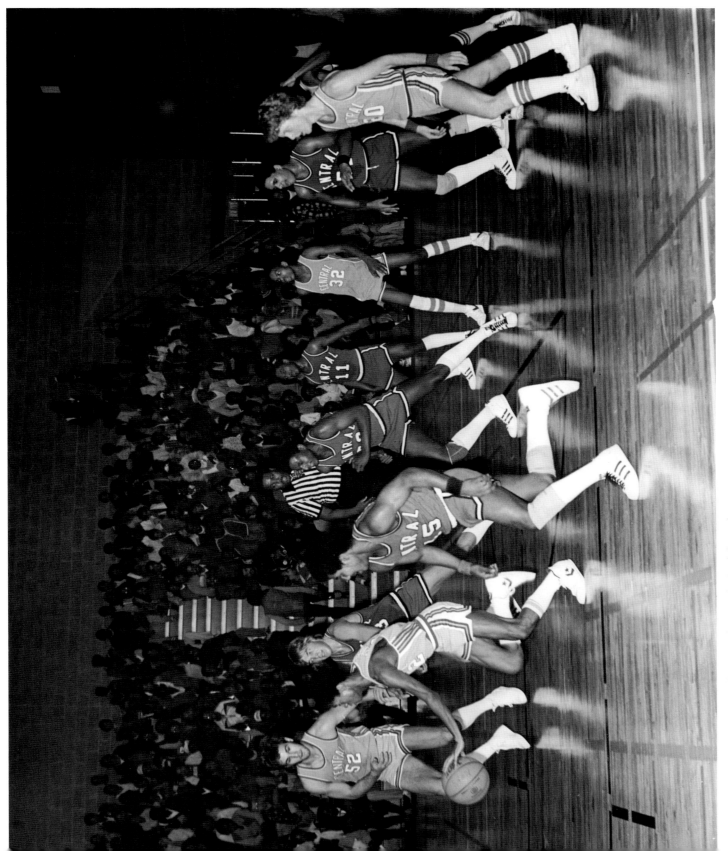

Minneapolis Central versus St. Paul Central

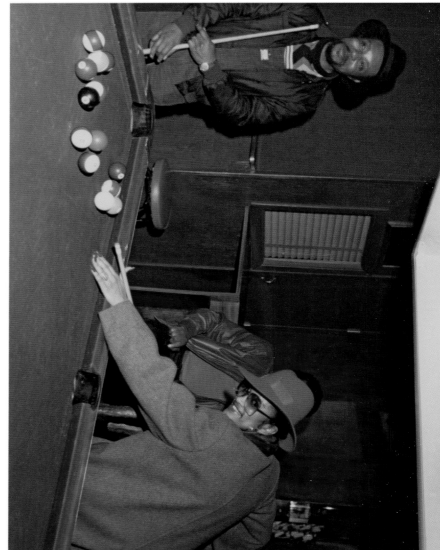

Playing pool at the
Riverview

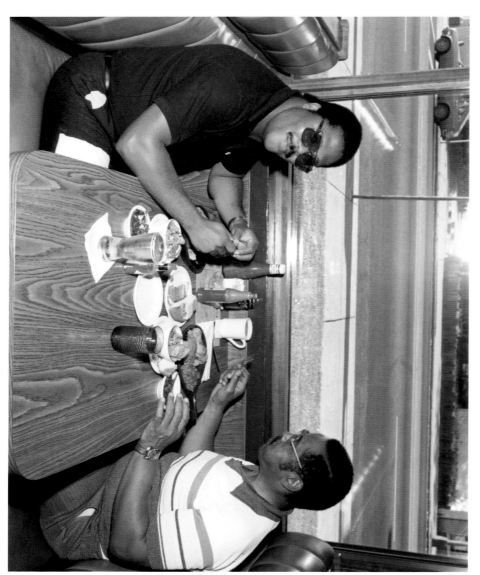

Two men eating soul food

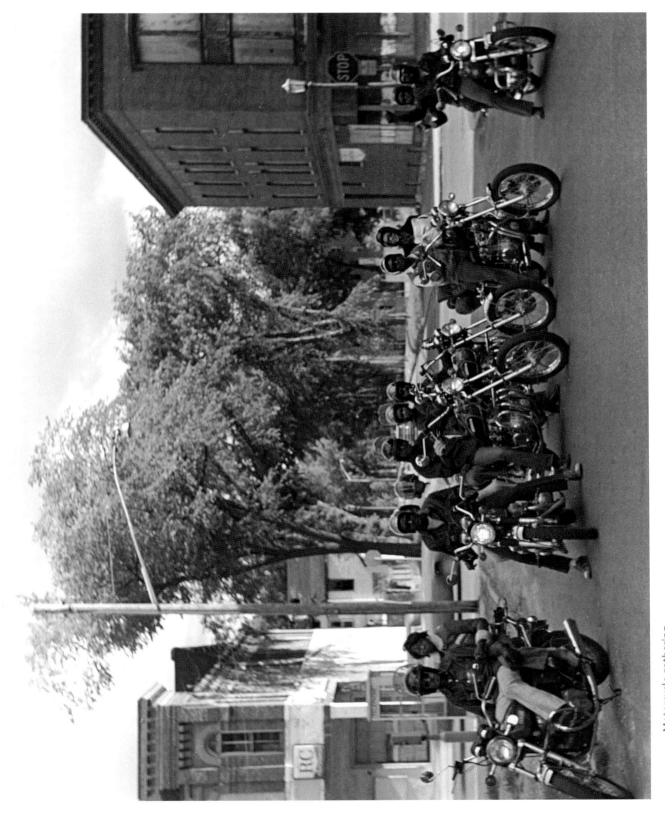

Motorcycle gathering

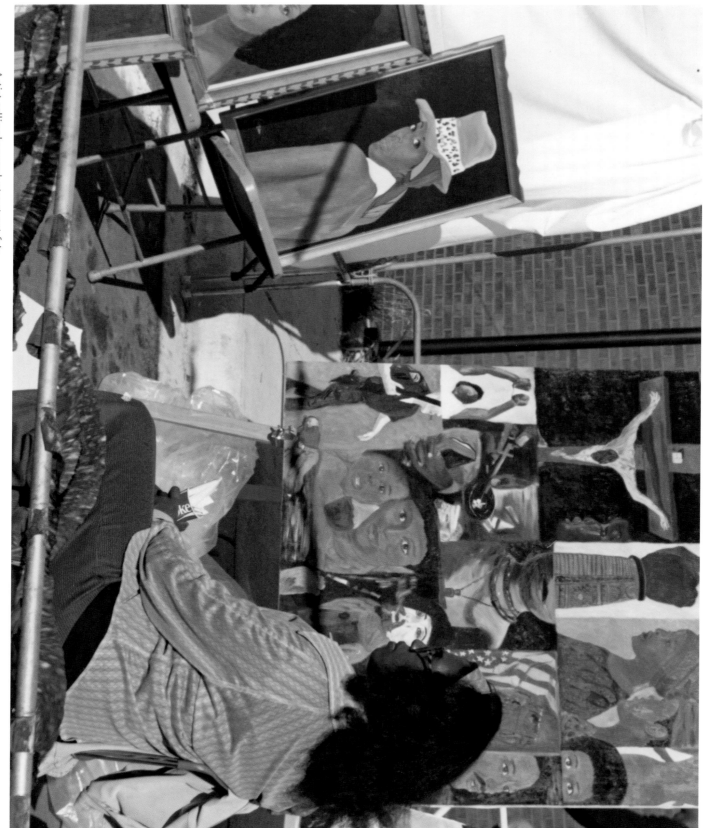

Artist selling her work at a street fair

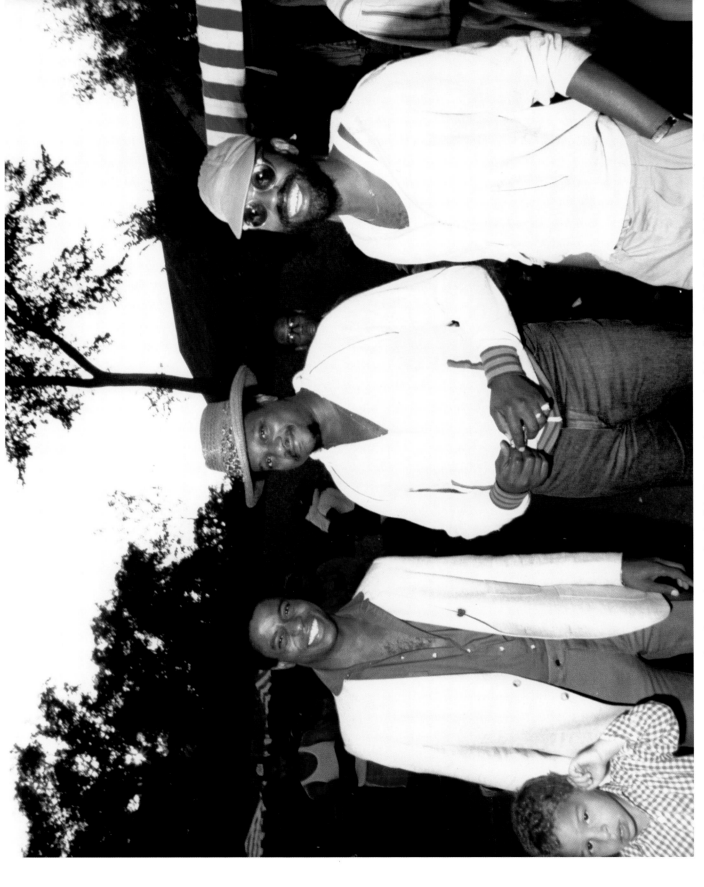

Musician Larry Loud, journalist Al McFarlane, and artist Seitu Jones at a Juneteenth celebration at Oak Park Center in North Minneapolis, 1988

Black Santa and kids

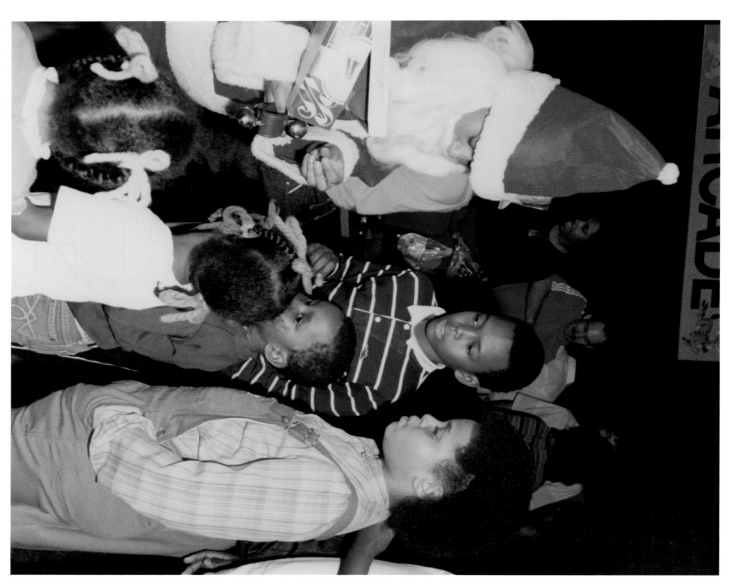

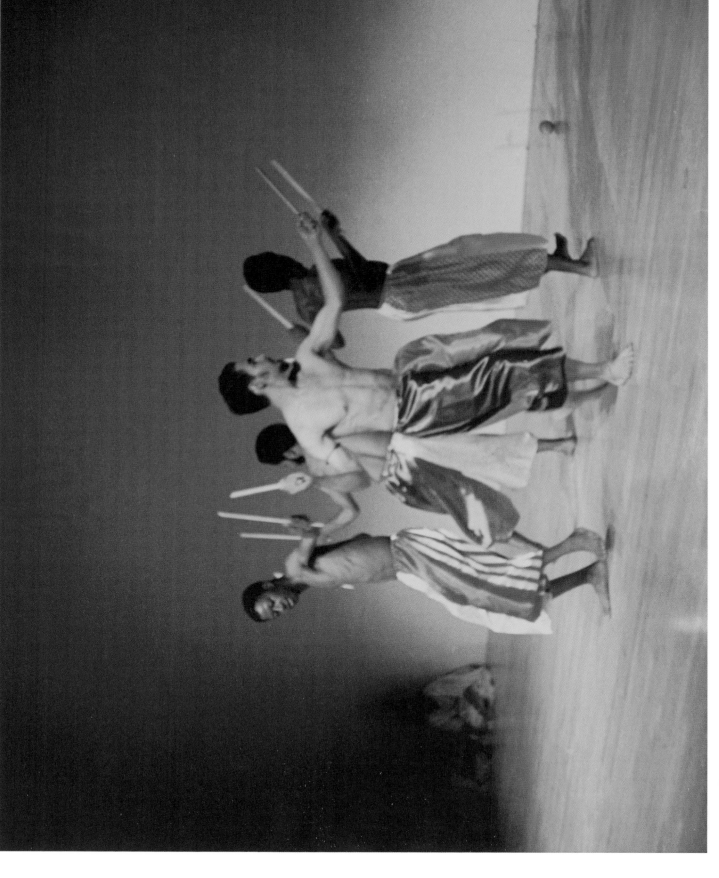

Dance troupe

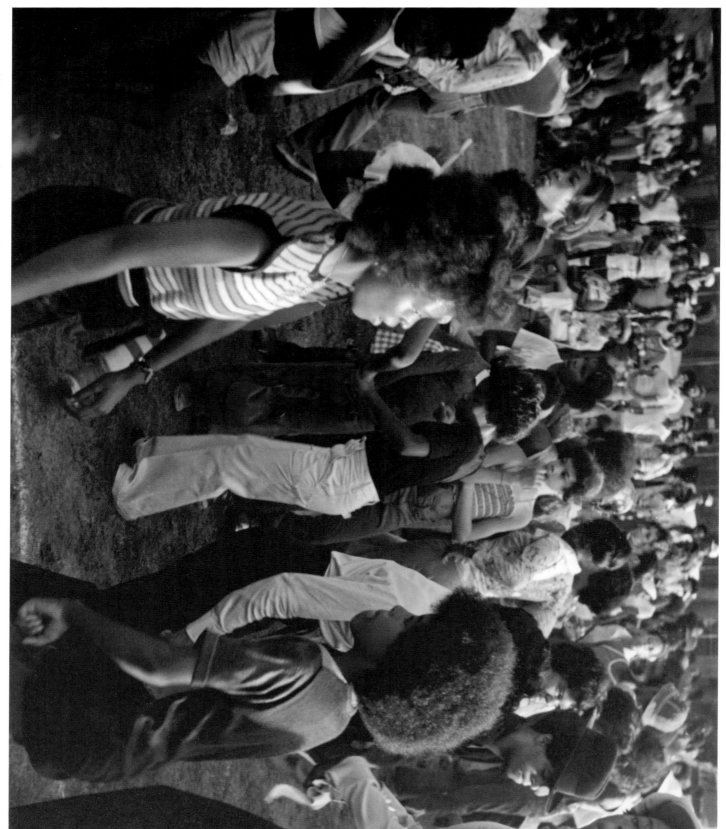

Young partygoers dancing at Powderhorn Park in South Minneapolis

ACKNOWLEDGMENTS

Many voices echo throughout the pages of this book.

First, thanks to my correspondents: photographer Glenn Gordon, musician and publisher Anthony Scott, Brian Engel, Mike Duffy, Professor John S. Wright, Torrie Jones, Chris Farstad, Bill Cottman, Laverne Scott of Elks Ames Lodge, Eric Foss of Secret Stash Records, Thornton "Pharaoh Black" Jones, Al McFarlane, Andrea Swensson, Kym "Mocha" Johnson, Kathleen Johnson, Sun Yung Shin, Wilbur Cole, "Wee" Willie Walker, and the former technician at Liberty Photo who asked to remain anonymous.

Texts referenced included Susan Sontag's classic *On Photography*; David Vassar Taylor's *African Americans in Minnesota*; historical newspapers such as *Insight News*, *Spokesman-Recorder*, and *Chicago Tribune*; *Insider Magazine*; Minnesota Public Radio News; Deborah Willis's *J. P. Ball: Daguerrean and Studio Photographer*; Ben Petry's essay "Sights, Sounds, and Soul" in *Minnesota History* magazine; Walter Scott's pictorials *Minneapolis Negro Profile* and *Minnesota's Black Community*; part two of Chris Williams's article "Jimmy Jam and Terry Lewis Have Become Synonymous with Recording Excellence" in *Wax Poetics*; Richard Wright's *12 Million Black Voices*; Maxine Leeds Craig's essay "Respect and Pleasure: The Meaning of Style in African American Life" from the catalog *Inspiring Beauty: 50 Years of Ebony Fashion Fair*; bell hook's *Black Looks*; Tanisha C. Ford's book *Liberated Threads: Black Women, Style, and the Global Politics of Soul*; Susannah Walker's *Style and Status: Selling Beauty to African American Women, 1920–1975*; Jon Kirby's essay in *Purple Snow: Forecasting the Minneapolis Sound*; and the Twin Cities Funk and Soul newsletter issued by Secret Stash Records. Also, a special thanks goes out to the archival librarians at Hennepin County Public Library and the Minnesota Historical Society.

On behalf of the missing voices: More research needs to be done on the black community in South Minneapolis's Central neighborhood as well as on the exchange of black culture and commerce among the Rondo, North Minneapolis, and South Minneapolis communities. There are, no doubt, plenty of stories left to be told about the black experience in Minnesota.

Lastly, to the memory of Charles Chambliss's good friend Roosevelt Gaines, who passed on during the early stages of this project. •

Text copyright © 2017 by Davu Seru. Other materials copyright © 2017 by the Minnesota Historical Society. All rights reserved. No part of this book may be used or reproduced in any manner whatsoever without written permission except in the case of brief quotations embodied in critical articles and reviews. For information, write to the Minnesota Historical Society Press, 345 Kellogg Blvd. W., St. Paul, MN 55102-1906.

www.mnhspress.org

The Minnesota Historical Society Press is a member of the Association of American University Presses.

Manufactured in the United States of America

10 9 8 7 6 5 4 3 2 1

⊛ The paper used in this publication meets the minimum requirements of the American National Standard for Information Sciences—Permanence for Printed Library Materials, ANSI Z39.48-1984.

International Standard Book Number

ISBN: 978-1-68134-064-7 (hardcover)

Library of Congress Cataloging-in-Publication Data available upon request.

Sights, Sounds, Soul was designed and set in type by Chris Long at Mighty Media, Minneapolis
Color image correction by Kelly Doudna

Charles Chamblis with
singer Erma Franklin